Marilyn in New York

We have New York photographer Ed Feingersh to thank for some of the most attractive photos ever taken of Marilyn Monroe. For example, the iconic image simply entitled "Chanel no. 5": Marilyn standing in front of the mirror in her New York hotel suite, putting the final touches to her evening dress – a touch of perfume to her décolleté.

Feingersh took the pictures during the so-called "New York exile" Marilyn went into early 1955 to sidestep the unacceptable constraints of her contract with Twentieth Century Fox and to take drama classes under Lee Strasberg. For an entire week Feingersh covered a Marilyn, who had just turned 29 and was gradually growing up, as she went about her private and public life in New York. He follows her around the city, accompanies her to a costume fitting at the Actors Studio, is with her on an incognito subway ride and her legendary ride atop a painted pink elephant in Madison Square Garden. The reader discovers a wonderful Marilyn Monroe, who can be seen in the spirit of optimism and radical changes that characterized 1955 to fluctuate between fresh self-confidence and extreme vulnerability, who can be vibrant and cheerful one minute and not long after pensive, dreamy, sad – you might say a Marilyn like you and me.

Ed Feingersh studied photography under Alexey Brodovitch at the New York School of Social Research and subsequently worked for many years as a reporter for the Pix, Inc. agency. His picture documentary of Marilyn was published in 1955 in the March issue of the magazine *Redbook*.

144 pages, 66 duotone plates

Marilyn in New York

Photographs by Ed Feingersh
from the Michael Ochs Archives

Edited and with an introduction
by Lothar Schirmer

Schirmer/Mosel

Reproductions: O.R.T. Kirchner & Graser, Berlin
Typesetting: Grafische Betriebe Biering, Munich
Printing and binding: Sing Cheong, Hong Kong

ISBN 978-3-8296-0353-9
A Schirmer/Mosel Production

"If I'm a star, then the people made me a star; no studio, no person, but the people did."

Marilyn Monroe

Marilyn in New York

At the end of 1954, Marilyn Monroe had under the supervision of her new mentor and manager, photographer Milton H. Greene, retreated from Hollywood and gone into so-called exile on the East coast. Here she either stayed in the Greene family's country home in Connecticut or spent her days in New York. The actual purpose of this move was to heal the wounds from her marriage to and subsequent divorce from Joe DiMaggio but at the same time to distance herself both emotionally and physically from the constraints and obligations of her contract with Twentieth Century Fox. This contract, which brought her a rather modest weekly salary of 1,500 dollars and denied her any say in the choice of film topics and roles, in no way corresponded with the star status Marilyn had achieved at the latest following the happy outcome of the calendar photo scandal in 1952 and her marriage to Joe DiMaggio in 1954. These two events and her movies *Niagara, Gentlemen Prefer Blondes* and *How to Marry a Millionaire* had brought her international headlines and transformed her overnight into one of the most famous actors in the Western world. While film critics might still turn up their noses at Marilyn's acting abilities, the public had immediately recognized with unerring instinct that this was somebody willing to give more than just their so-called best.

Backed by the sympathy of her not inconsiderable international public, Marilyn was in a position to exert a certain pressure on Twentieth Century Fox by simply distancing herself from movie work. Initially, the industry looked down on her behavior as a kind of sit-down strike. Moreover, her argument that she sought to perfect her training as an actress made it even more difficult for the movie company to talk about deliberate breach of contract.

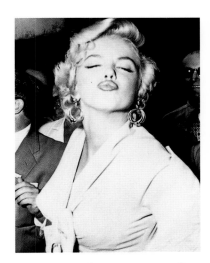

A Marilyn kiss for Weegee, New York's most famous roving photo-reporter, upon his arrival at the set of The Seven Year Itch, *1954*

7

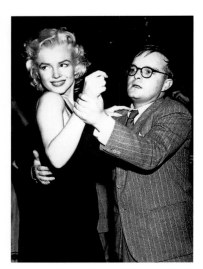

Marilyn and Truman Capote at El Morocco, 1955

In order to substantiate her own insistent demand that she be taken more seriously both artistically and financially, she began taking acting lessons under Lee Strasberg in the famous Actors Studio, New York. At the arrangement of her writer friend Truman Capote she also sought out Constance Collier, who was one of the greatest Shakespearean actors in the English-speaking world before establishing herself as a drama teacher for stage and screen stars in New York. Constance Collier provided what is arguably the shrewdest and equally most tender description of Marilyn's character. Truman Capote cited Ms. Collier as follows: 'Oh, yes,' Miss Collier reported to me. 'She is a beautiful child. I don't mean that in the obvious way – the perhaps too obvious way. I don't think she's an actress at all, not in the traditional sense. What she has – this presence, this luminescence, this flickering intelligence – could never surface on the stage. It is so fragile and subtle, it can only be caught by the camera. It's like a hummingbird in flight: Only a camera can freeze poetry of it. But anyone who thinks this girl is simply another Harlow or harlot or whatever is mad. Speaking of mad, that's what we've been working on: Ophelia. I suppose people would chuckle at the notion but really she could be the most exquisite Ophelia. I was talking to Greta [Garbo] last week and I told her about Marilyn's Ophelia, and Greta said that yes she could believe that because she had seen two of her films, very bad and vulgar stuff, but nevertheless she had glimpsed Marilyn's possibilities. Actually, Greta has an amusing idea. You know that she wants to make a film of *Dorian Gray* with her playing Dorian of course. Well, she said she would love to have Marilyn opposite as one of the girls Dorian seduces and destroys. Greta! So unused! Such a gift – and, rather like Marilyn's if you consider it. Of course, Greta is such a consummate artist, an artist of the utmost control. This beautiful girl is without any concept of discipline and sacrifice. Somehow I don't think she'll make old bones. Absurd of me to say but somehow I feel she'll go young. I hope, I really pray that she survives long enough to free that strange, lovely talent that's wandering through her like a jailed spirit.'"

The photographs in this book were produced around the time that Constance Collier practiced Ophelia. They confirm Ms. Collier's assessment word for word.

Not only artistically was Marilyn in the most capable hands, but also commercially and legally. Milton Greene and his lawyer Frank Delaney set up a film production company for Marilyn to provide a legal support for the seriousness of Marilyn's wish for independence. Marilyn was made President of "Marilyn Monroe Productions, Inc.," Milton Greene Vice President. Admittedly, the new firm could not yet make direct use of its most valuable asset, Marilyn's acting skills. The old contract with Twentieth Century Fox forbade her from working for anyone else. But the company nonetheless attracted lots of headlines, and at the press conference called to announce this event on January 7, 1955 Marilyn added some spice as only she knew how:

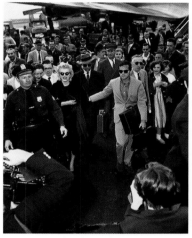

Marilyn and Milton Greene arrive at New York's Idlewild airport on June 2, 1955 after the completion of shooting Bus Stop.

MM: "I formed my own corporation so I can play the better kind of roles I want to play. I didn't like a lot of my pictures. I'm tired of sex roles. I don't want to play sex roles anymore."

Press: "What role would you like to play?"

MM: "I don't know. I'd like to play one of the parts in 'The Brothers Karamazov' by Dostoyevsky."

Press: "Do you want to play the Brothers Karamazov?"

MM: "I don't want to play the brothers. I want to play Grushenka. She's a girl."

Incidentally, Marilyn had only arrived an hour late, and a whole host of famous colleagues attended the conference in support of her, including stars such as Janet Leigh, Tony Curtis and Marlene Dietrich.

Setting up the production company established Marilyn as a cinematic queen with her own kingdom, albeit imaginary for the time being; what was lacking, however, was an opportunity to employ her artistic talents. It was decided to compensate for this by staging public appearances designed to attract maximum public attention. A constant flow of news was to remind the powers that be at Twentieth Century Fox as often as possible of the sad truth that their most valuable movie star, whom the public was dying to see, was not available, nor would she become available, unless they were to agree to what were still felt to be rebellious demands.

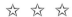

One of the first of such public events at which Marilyn presented herself to advantage as in a happening, was the premiere of Elia Kazan's movie *East of Eden*, which made James Dean into an international star overnight. It took place on March 9, 1955 as a charity event for the Actors Studio in the Astor Theater, New York. In elegant evening dress Marilyn made a striking and much admired appearance as usherette for the guests to the premiere. The allusion to her double role as a fairy tale Cinderella and Princess was more than obvious. Unfortunately, James Dean did not attend the opening night so that the planned photogenic summit of the media giants fell flat. But even without Dean the public response was remarkable enough.

Ed Feingersh documents two other carefully orchestrated public appearances by Marilyn in the photographs featured in this book: Marilyn's visit to the New York premiere of Tennessee Williams' play *Cat on a Hot Tin Roof*, which she attended with Milton Greene on March 24, 1955 in the Morosco Theater, and almost a week later Marilyn's spectacular ride on a pink elephant as part of a large charity gala by the Ringling Brothers and Barnum & Bailey Circus in New York's Madison Square Garden organized by Mike Todd, recent spouse of Liz Taylor. Incidentally, the man who acted as circus director in the arena — this too possibly a small poisoned arrow for Hollywood — was Milton Berle, who was

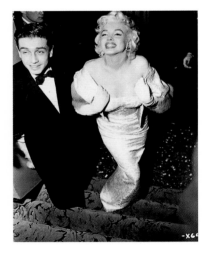

Marilyn and a companion arrive at the premiere of East of Eden *in New York on March 9, 1955.*

moderating the most famous TV show in the United States at the time. Some 200 photographers jostled for the best places from which to take photos when Marilyn rode into the arena on the elephant, and Milton Berle had to call them to order several times so as not to jeopardize the continuation of the show.

Variety, the magazine of the entertainment industry, described the commotion as follows: "The tableau was climaxed by Marilyn Monroe atop a painted pink pachyderm. The photos really messed up the procession, crowding the path of the slightly clad film star in a manner that impeded progress and movement. Miss Monroe's natural attributes are hard to follow, but eventually, the crowd got over it."

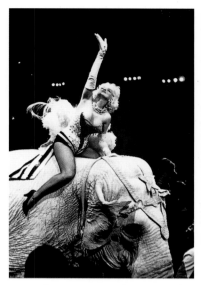

At Madison Square Garden on March 30, 1955: the famous ride on the pink elephant.

Milton Greene, who had no intention of leaving anything to chance as regards the picture coverage of Marilyn, had for this week (namely March 24 to March 30, 1955) engaged the services of New York photo-reporter Ed Feingersh as the personal photographer who would be attached to Marilyn. It was an excellent choice. The man: one of the many nameless yet highly-talented photographers of which New York city has such a rich supply. We must thank him for what are arguably the most attractive Marilyn photographs. Watchfully Ed Feingersh follows Marilyn as she makes her way around the big city. The stops correspond with her daily routine: hotel room, street, coffee shop, subway, the theater, dress rehearsal, the circus. The photographs produced in this week and which outshine all other Marilyn photographs speak of a rare and strange intimacy between photographer and his famous model. So intimately and sensitively does Ed Feingersh capture Marilyn's emotional state fluctuating constantly between arrogant self-confidence and extreme vulnerability that at first sight you might think they were private photos, they seem so natural. But a great deal of acting was also involved. For instance, when he presents Marilyn on the subway platforms and in its wagons in the role of the girl next door on her way to work. You might say an approachable Marilyn. Marilyn, who here for the first time presents herself as a woman with a career to attend to, sets about distancing herself immediately

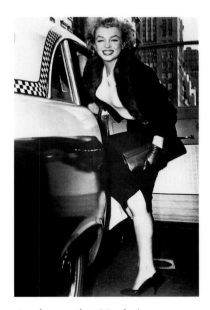

A radiant smile is Marilyn's most precious gift.

and irrevocably from the glamor doll of the early 1950s. As such the photographs by Ed Feingersh are most certainly part of the image shift that Marilyn and Milton Greene sought. And perhaps it is precisely this sense of optimism and determined new beginnings in the photographs that make them seem so moving to today's observer, who is aware of how the story ends.

Indeed the title of the article in the July issue of the magazine *Redbook*, which featured some of these photographs by Ed Feingersh, was simply "The Marilyn Monroe you have never seen".

Thanks to the support from her public, Marilyn emerged as the outright winner of the poker game with the Twentieth Century Fox bosses. June 1, 1955, her 29th birthday, is the premiere of the film she made the previous year with Twentieth Century Fox under the direction of Billy Wilder – *The Seven Year Itch*. Since Marlene Dietrich's legendary cabaret scene on the barrel in *Der Blaue Engel* there has been no comparable erotic electricity of the kind to have such an international public impact as that triggered by the warm air from the subway grid that exposed Marilyn's legs. The success of the film was so overwhelming that the shareholders of Twentieth Century Fox joined the enthusiastic public and forced the management to finally meet Marilyn's wishes.

On December 31, 1955, when Marilyn signs a new contract, which commits her to four films for the company in the next seven years and gives her a say in the topic, director and cameraman, her victory is complete. Moreover, she is no longer exclusively bound to Twentieth Century Fox, and Marilyn Monroe Productions, Inc. can now actually start working. At the beginning of January 1956, Marilyn, whose modest beginnings as a pin-up model were almost exactly ten years before, tells an astonished film industry that she has acquired the film rights for the play *The Sleeping Prince* by Terence Rattigan and plans to make a film of it with Sir Laurence Olivier as the leading man at her side. Six months

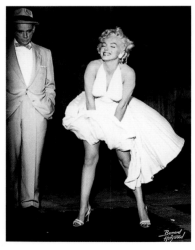

A draft of air that made history: Marilyn in the early morning hours of September 13, 1954 at the corner of Lexington Avenue and 52nd Street in New York.

later she announces her marriage to playwright Arthur Miller to New York reporters. She has reached the zenith of her career.

Ed Feingersh presented us with a week in photographs from the year 1955, which was so decisive for Marilyn's career. But not only for her is it a year of major events. It is also the year that James Dean dies, who that same year made two of the three films that would make him immortal. Also in 1955 with his rock'n'roll Elvis Presley sets the South of the United States and later the entire music world on fire.

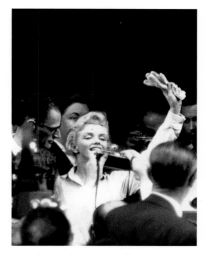

Marilyn and Arthur Miller announce their wedding plans at a press conference in New York in late June 1956.

Plates

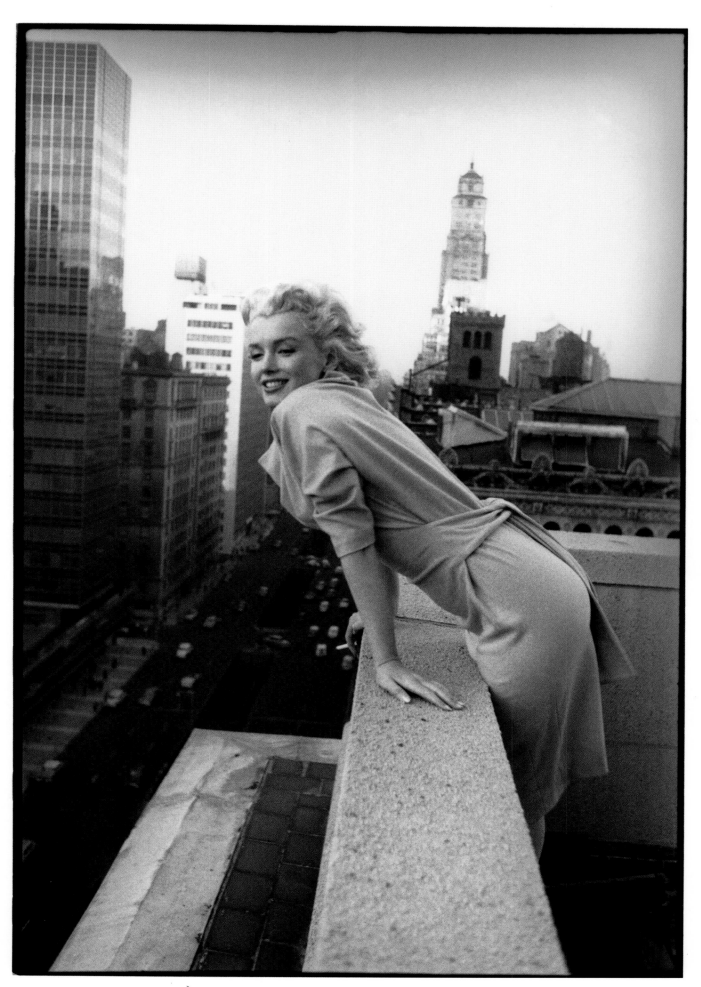

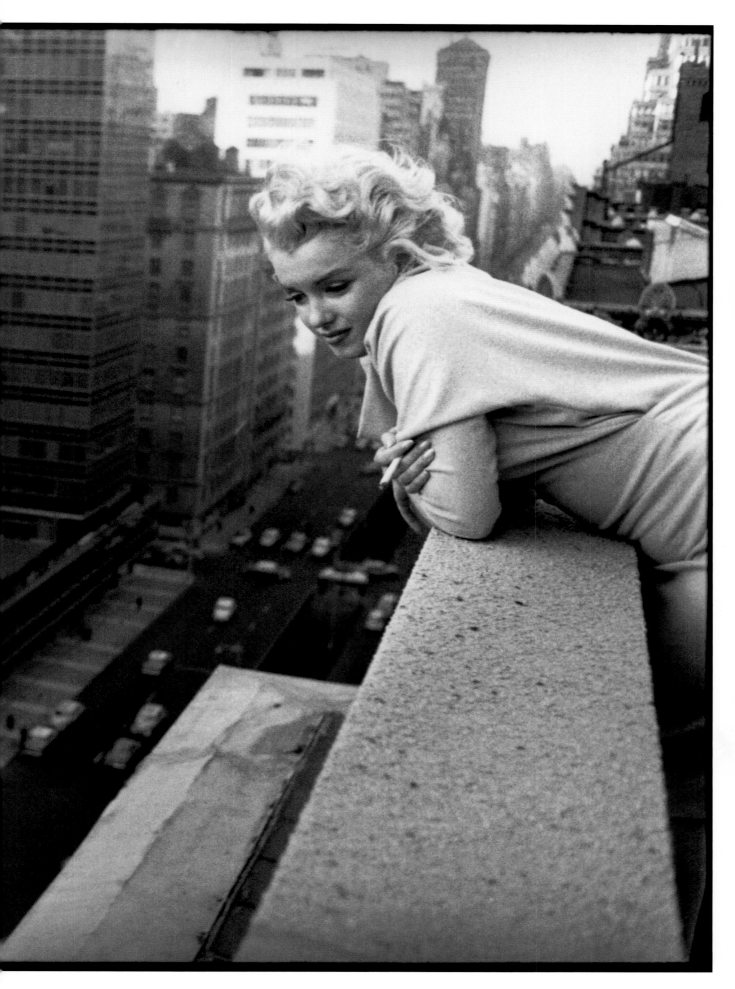

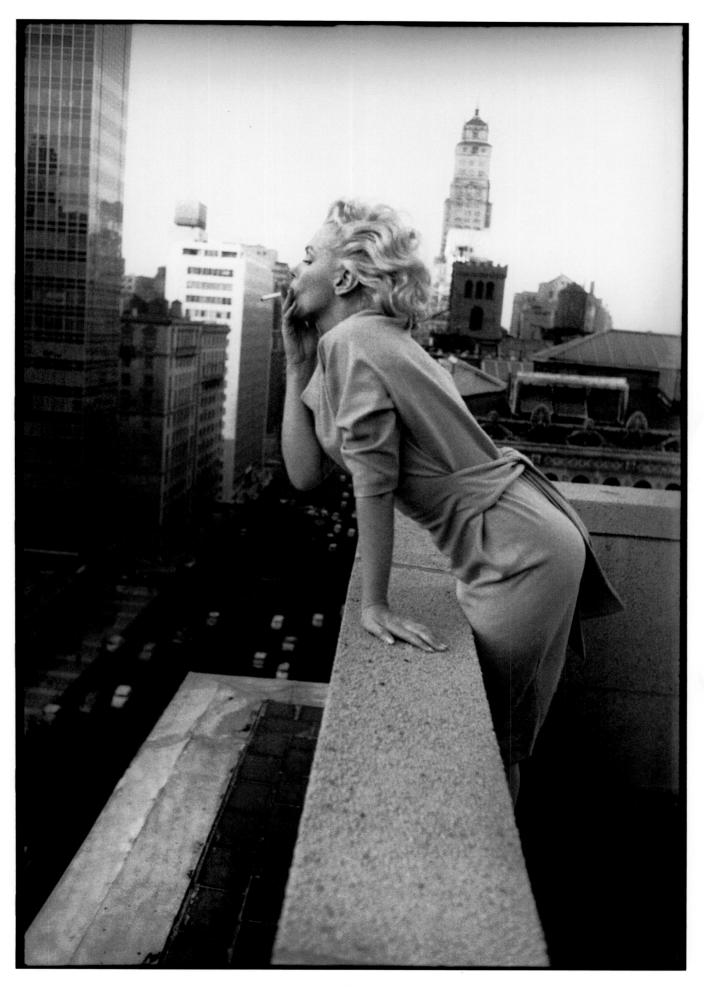

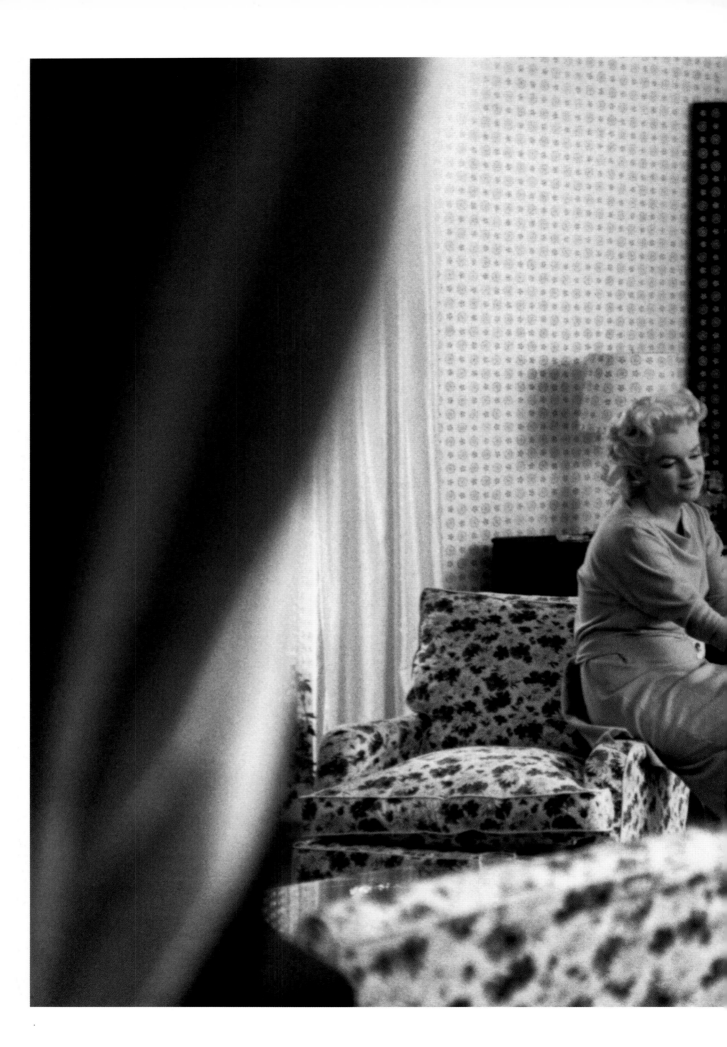

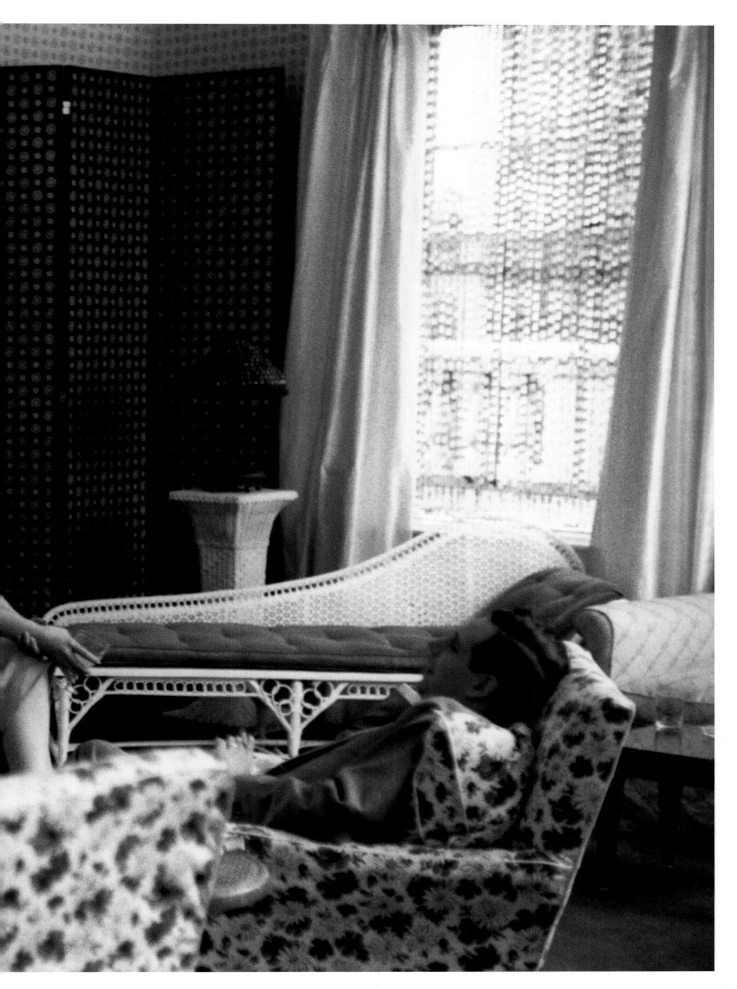

PLATES 4–10
*Marilyn talking with her agent Richard Shepherd
in her suite in the Ambassador Hotel.*

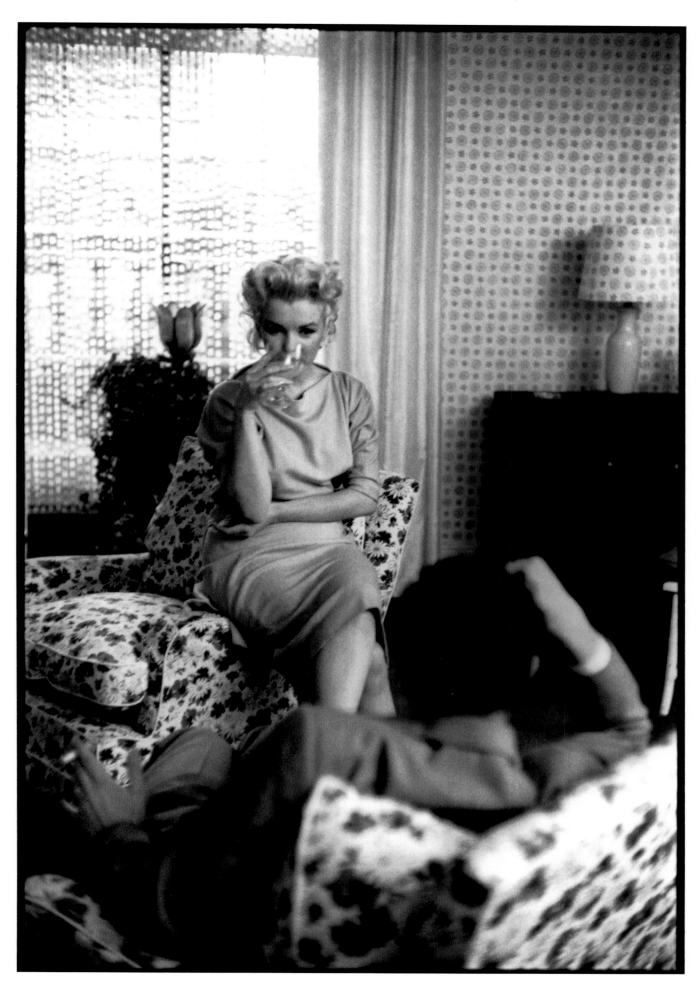

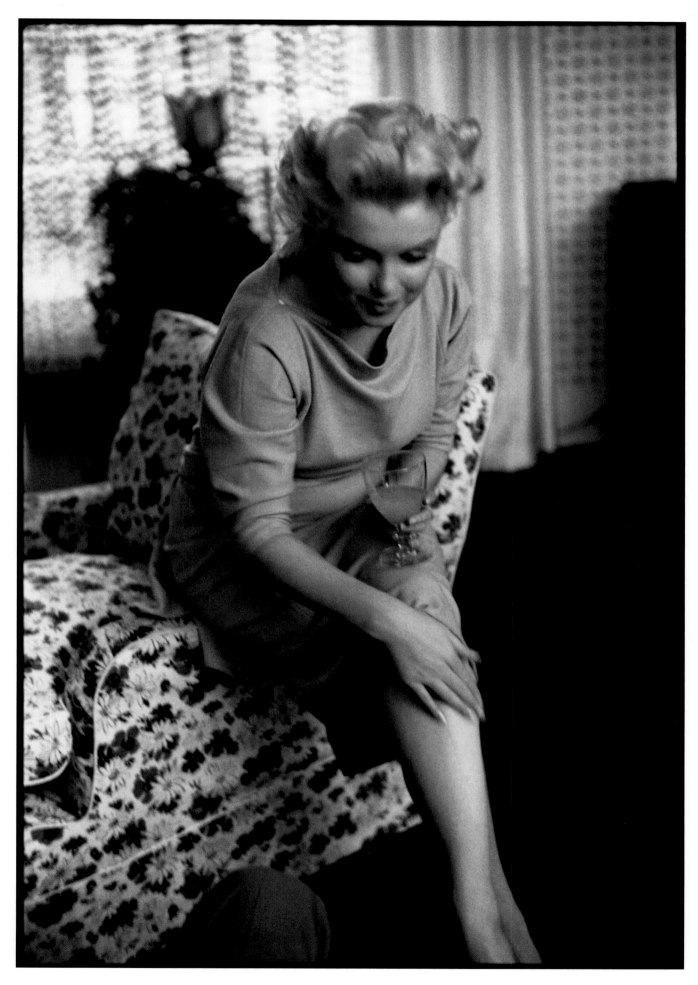

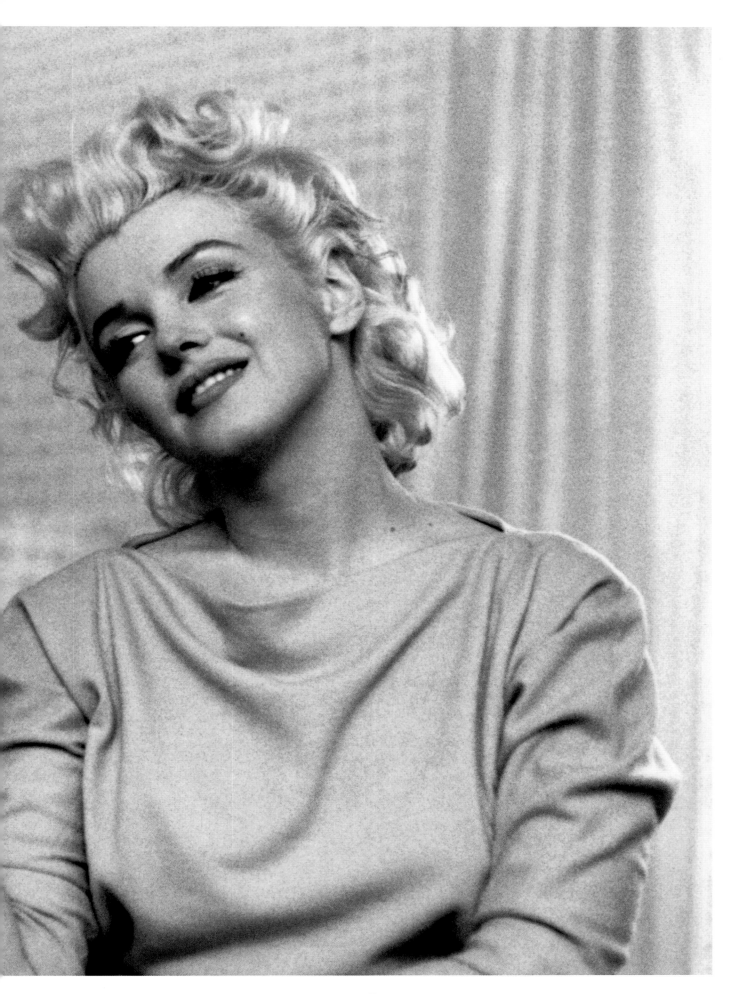

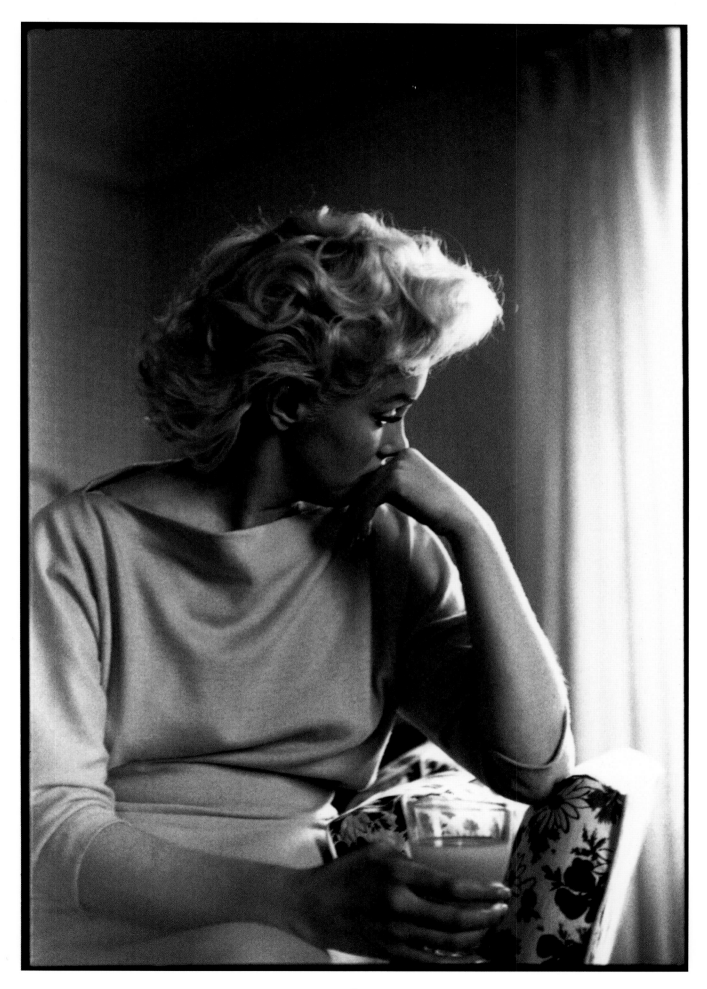

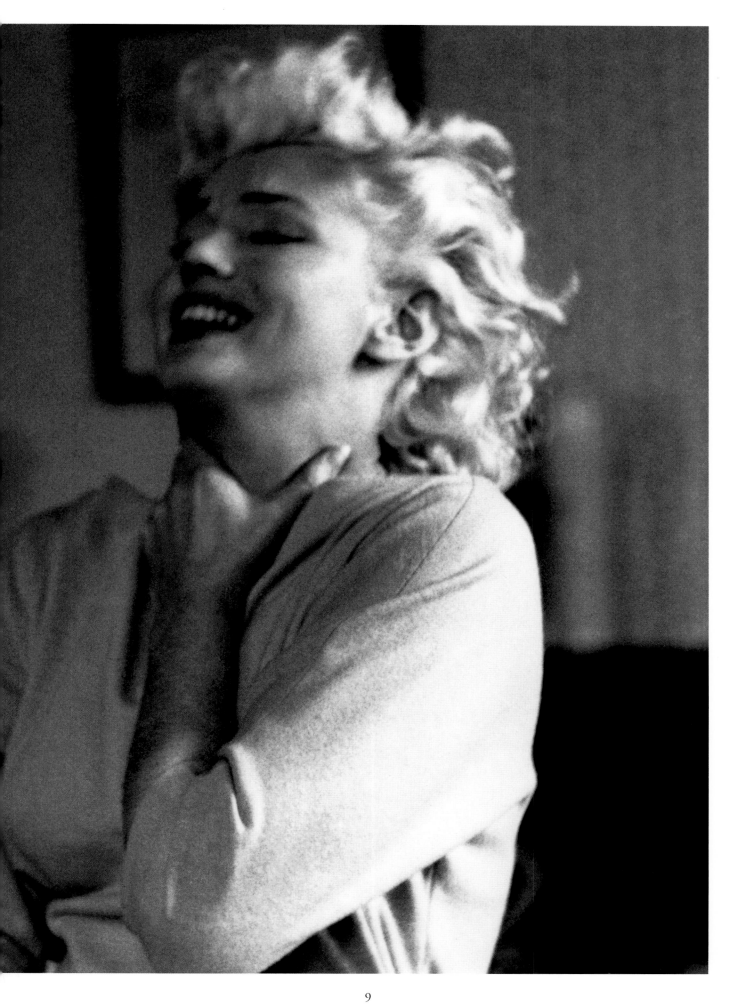

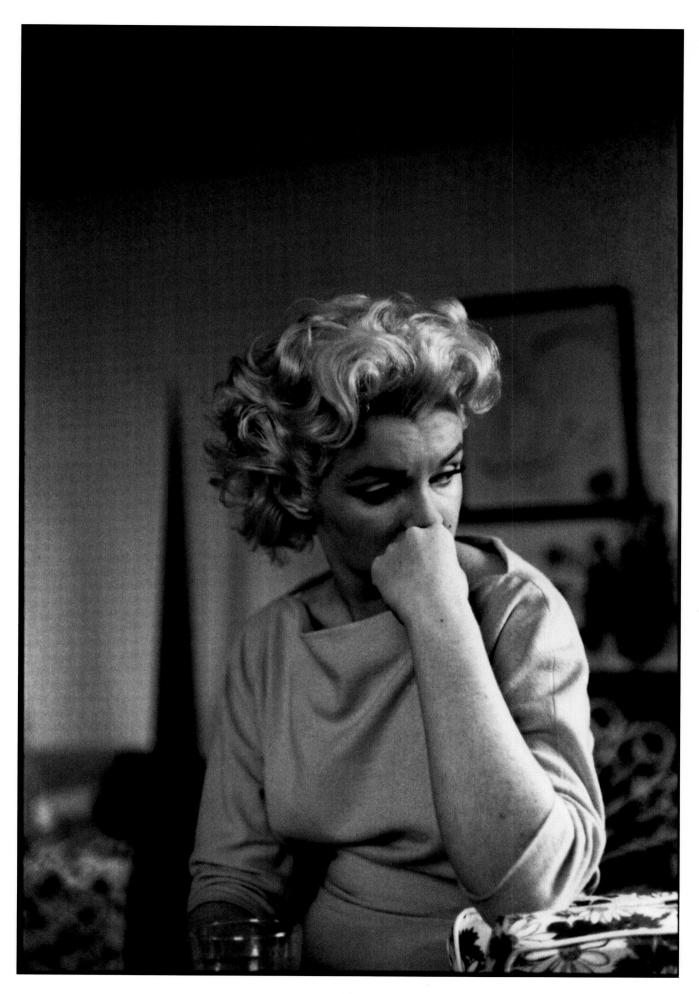

PLATES 11–13
Marilyn, reading in her hotel suite.

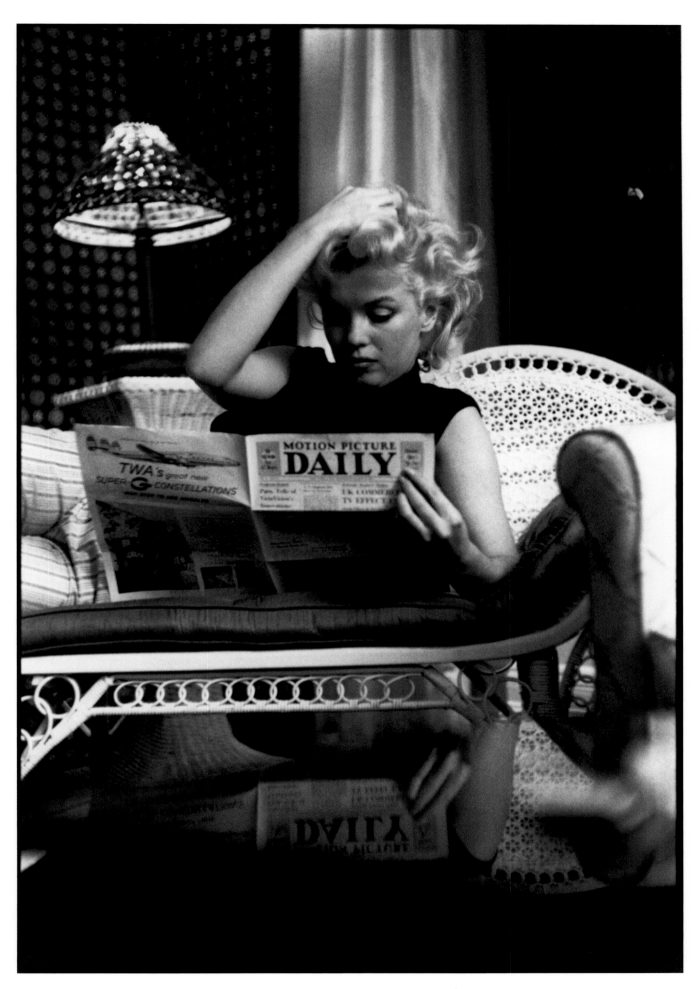

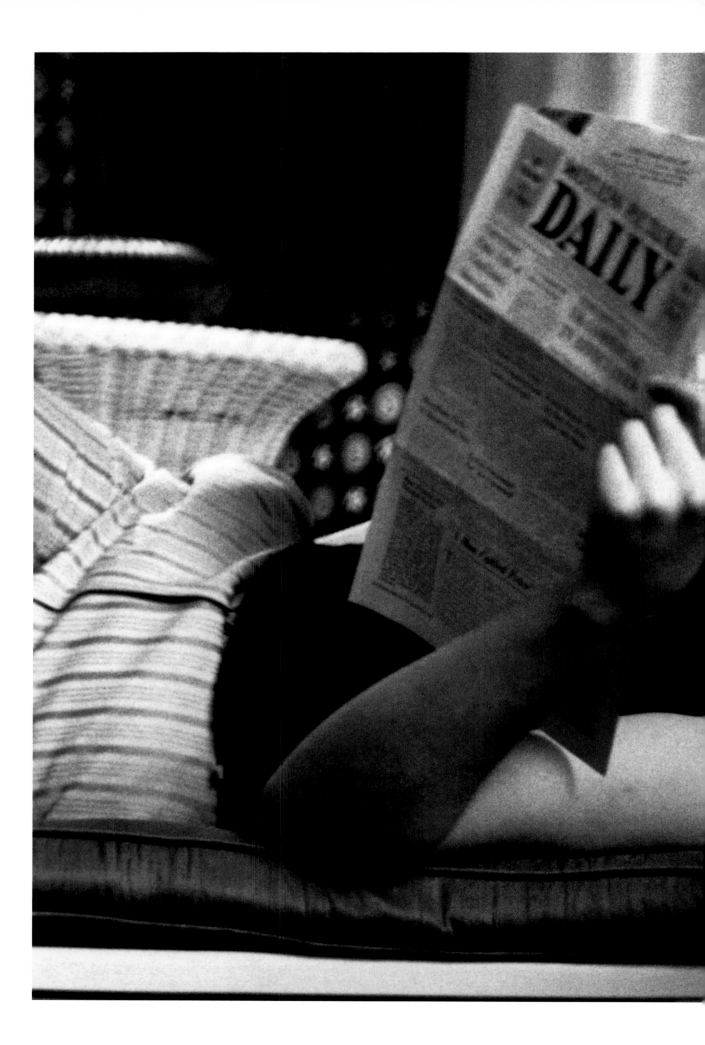

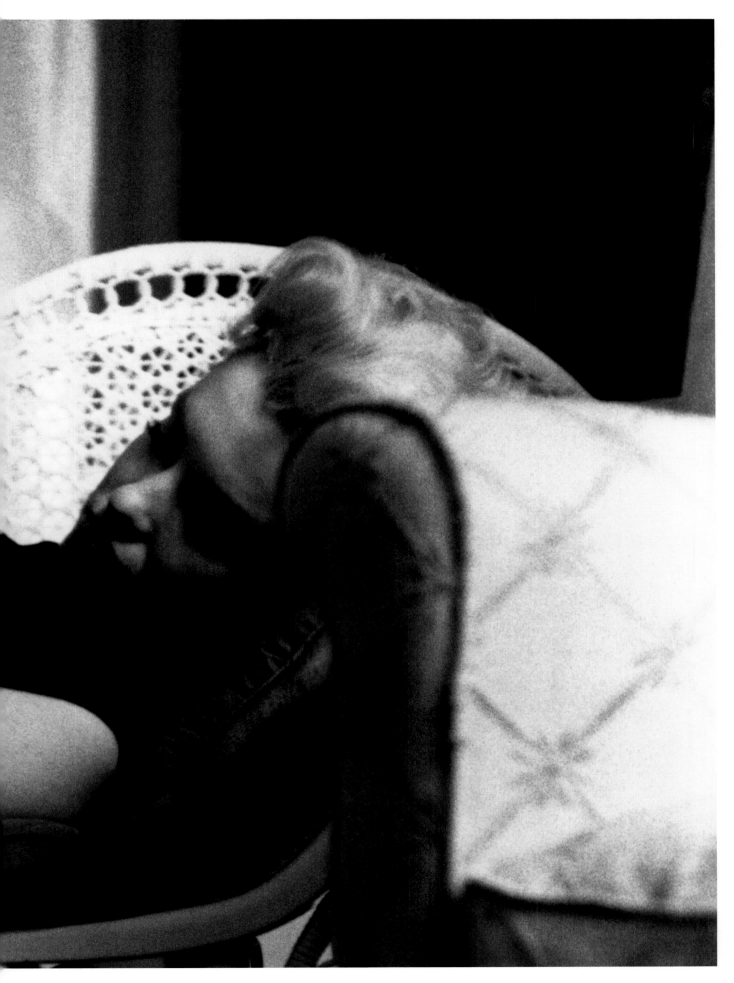

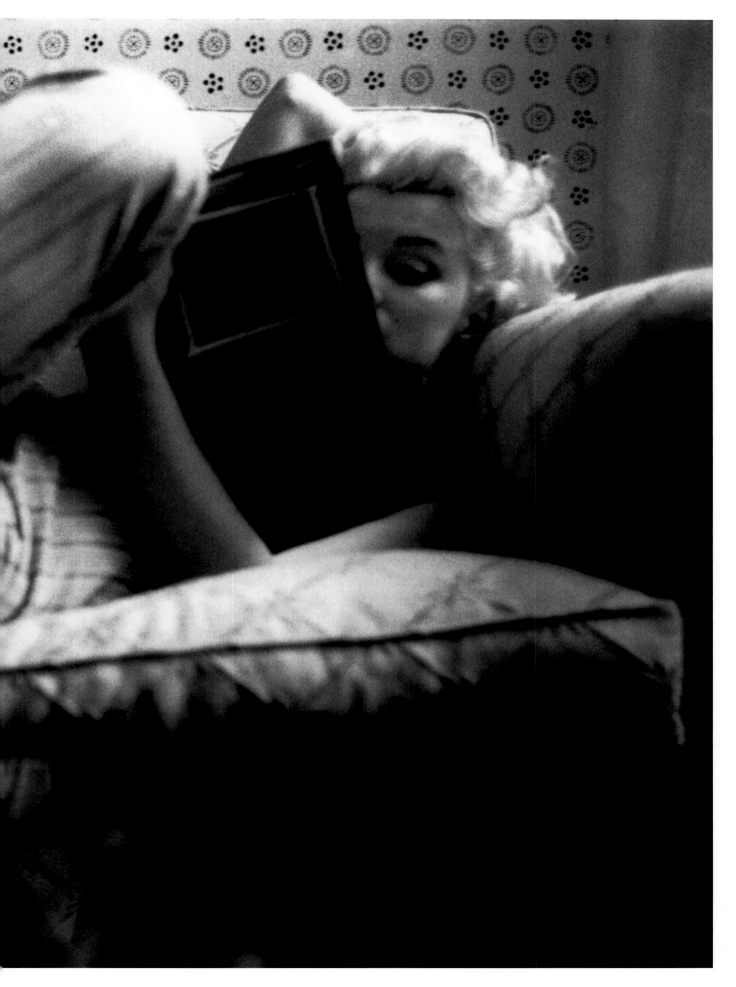

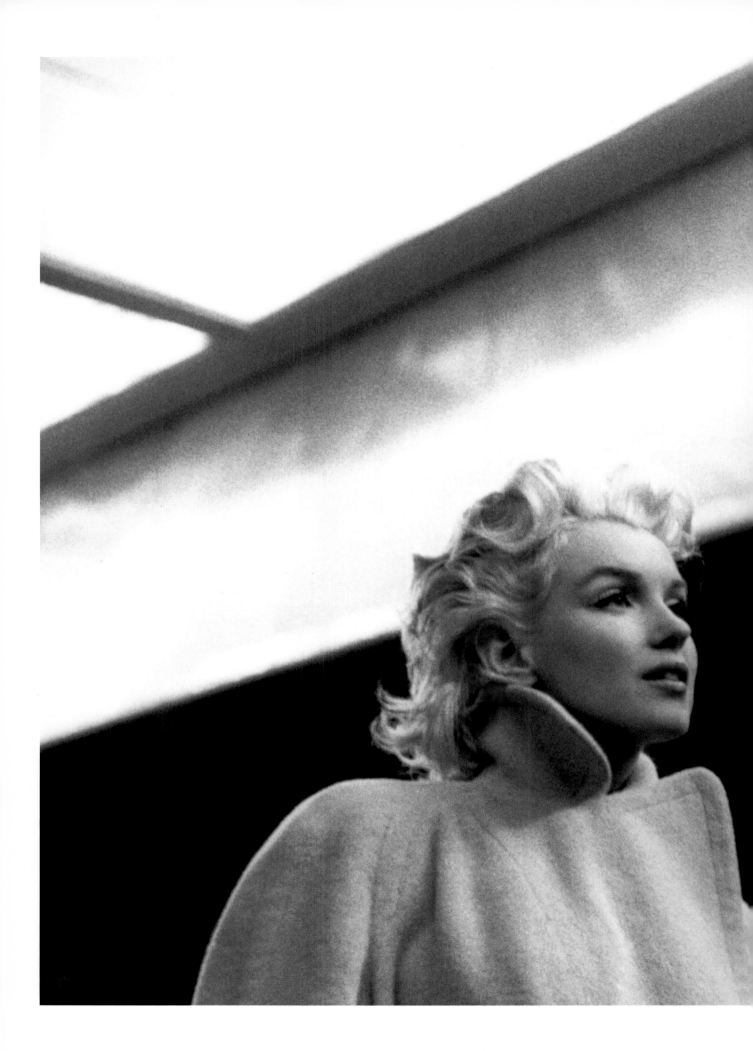

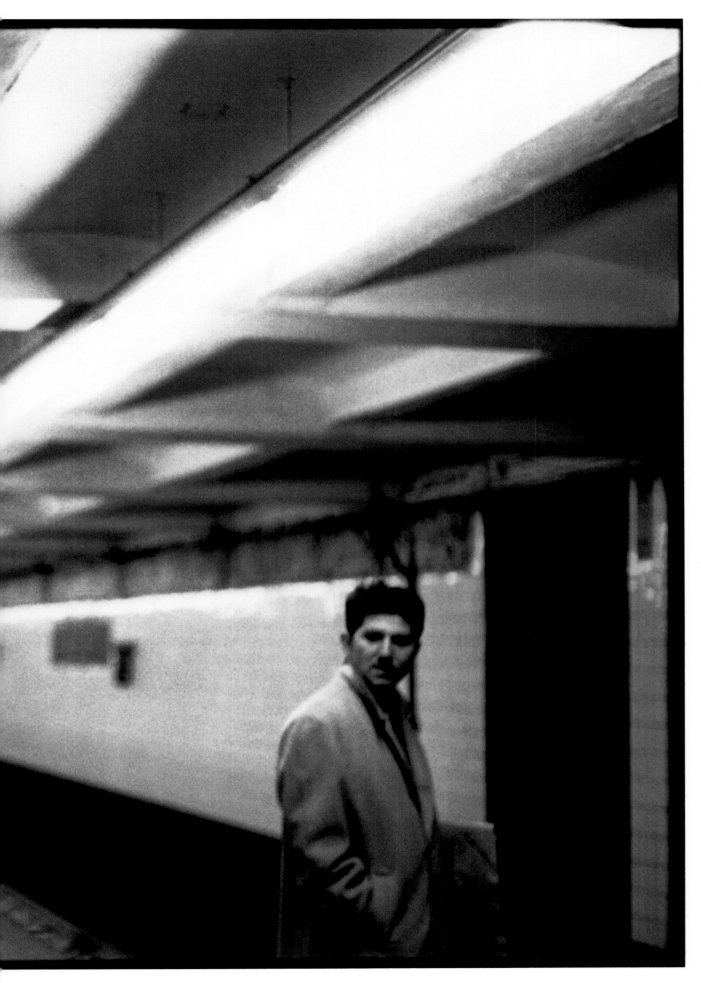

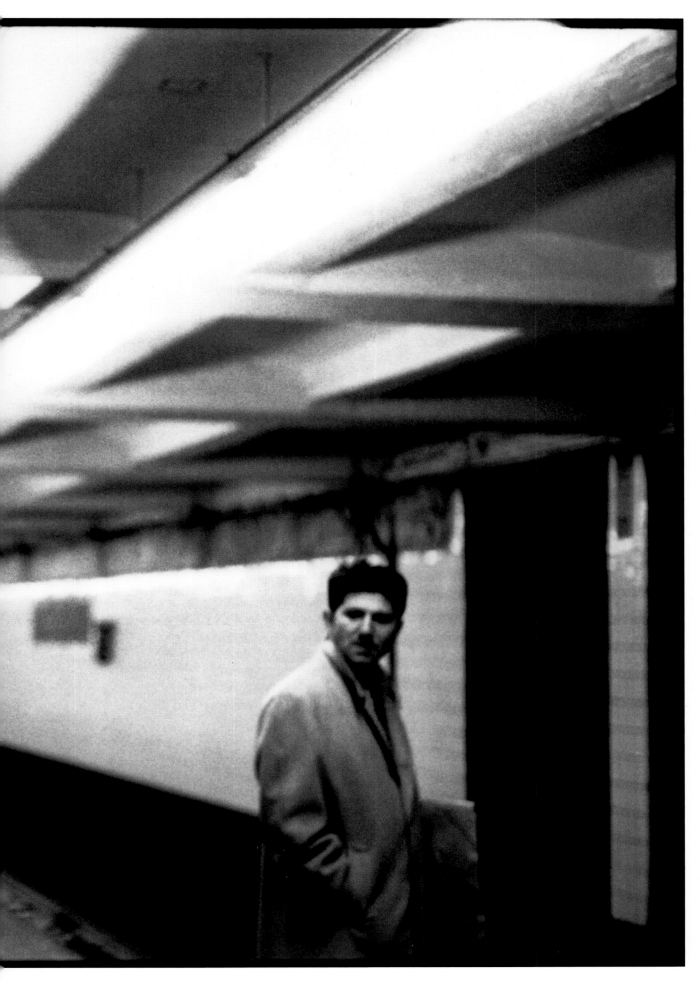

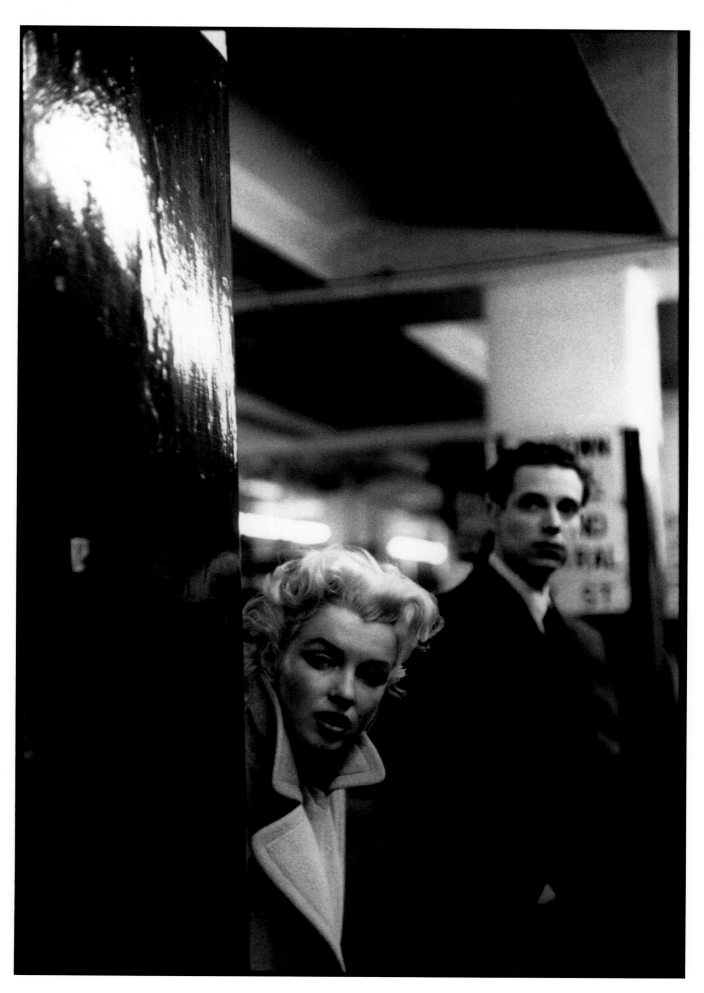

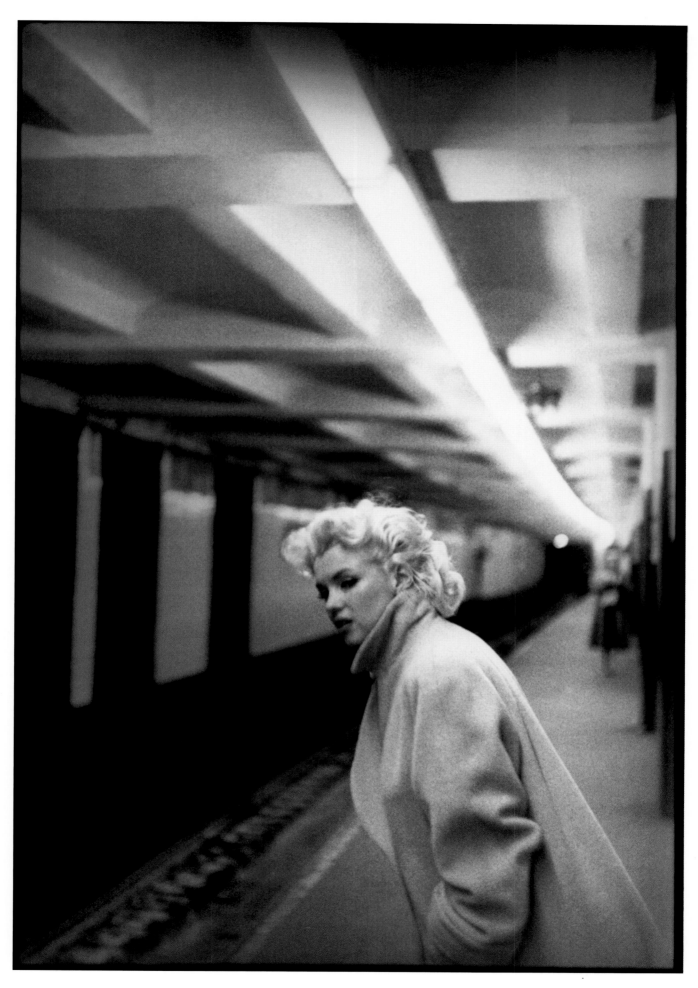

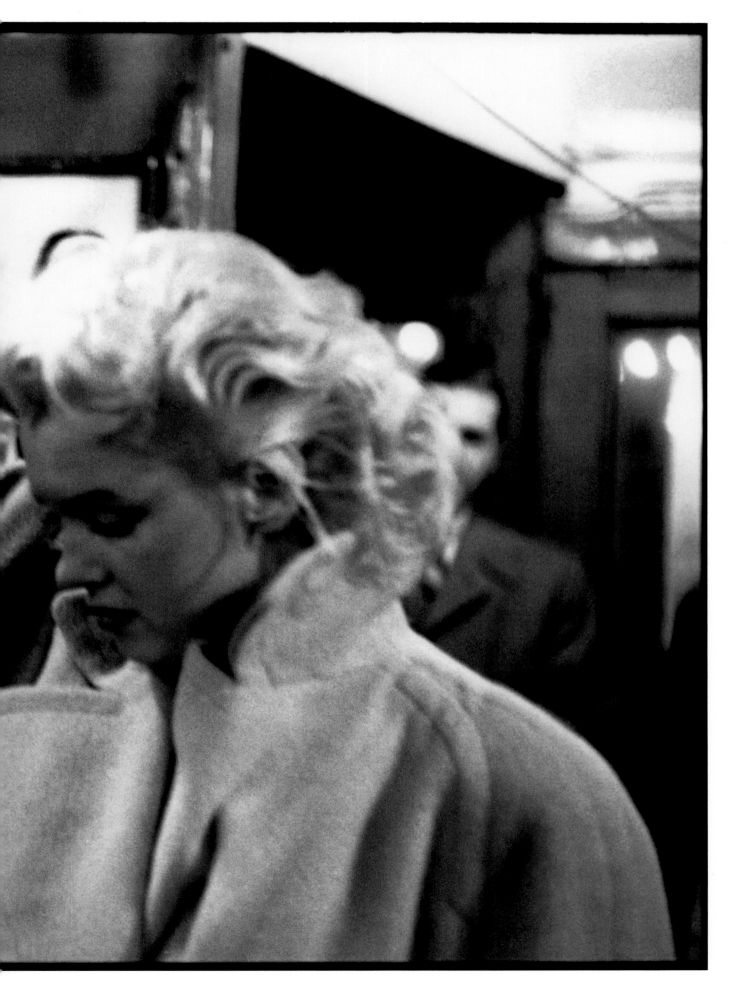

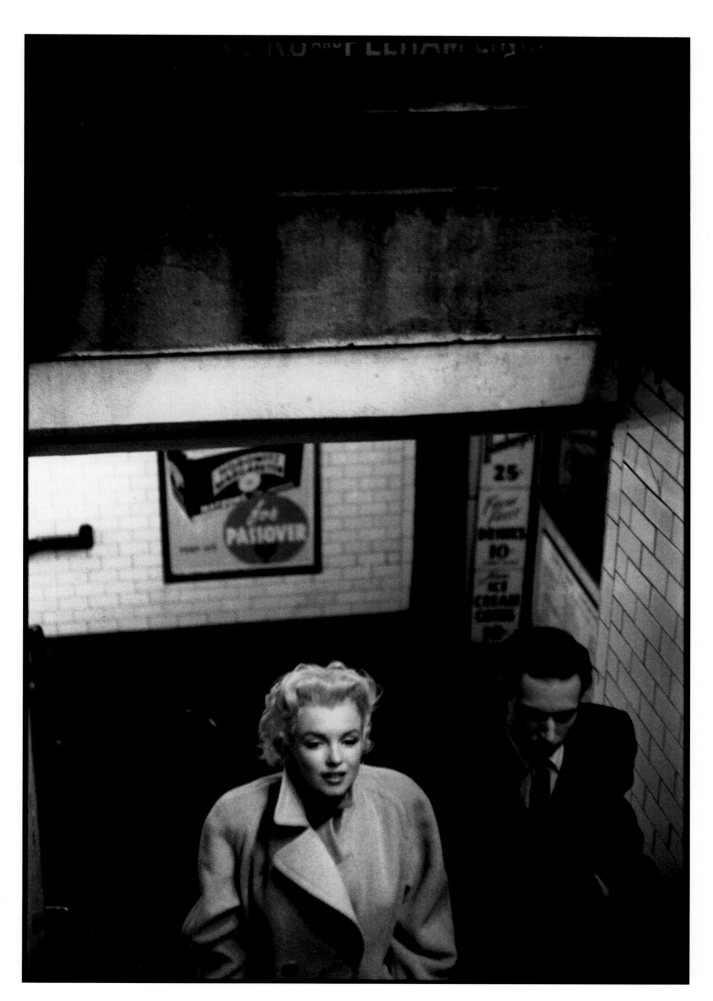

21

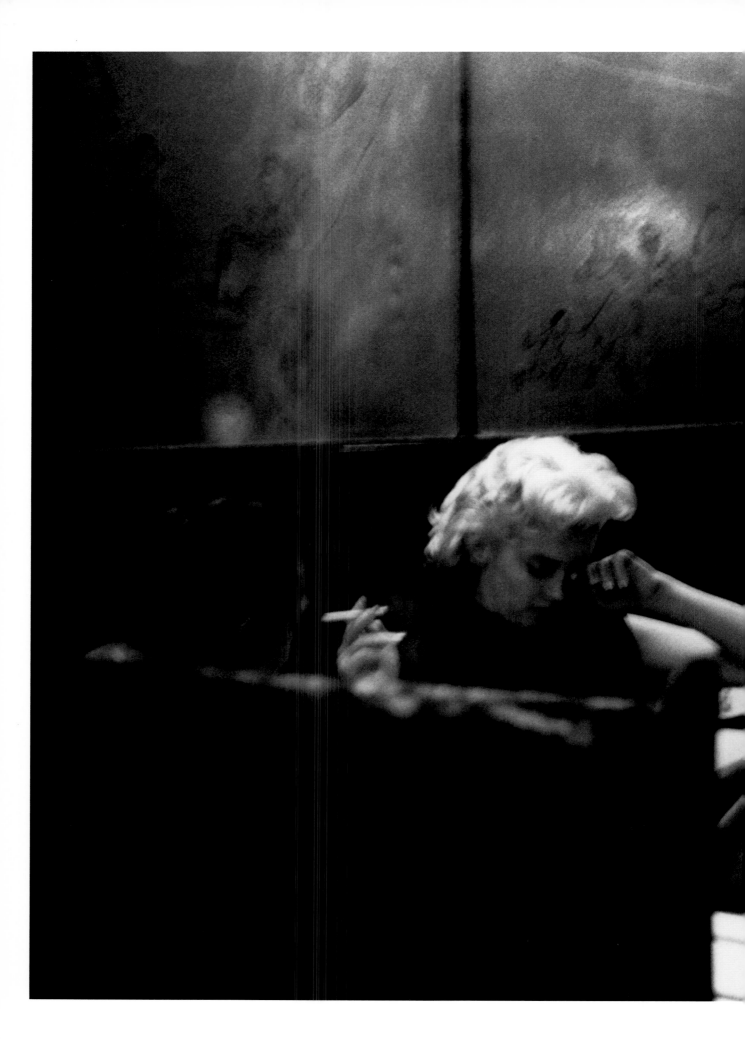

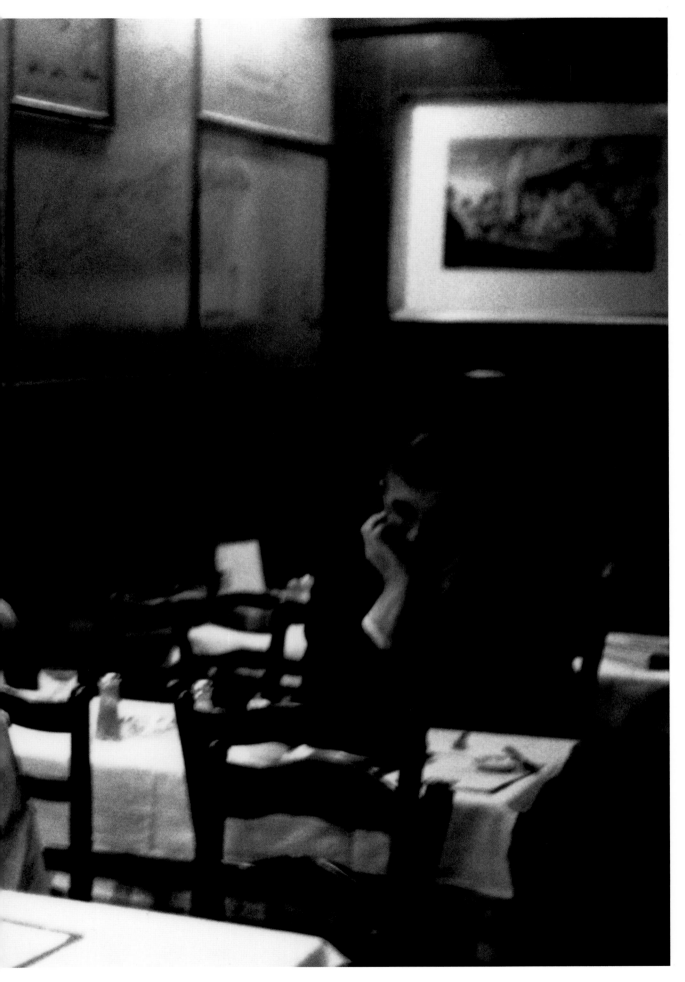

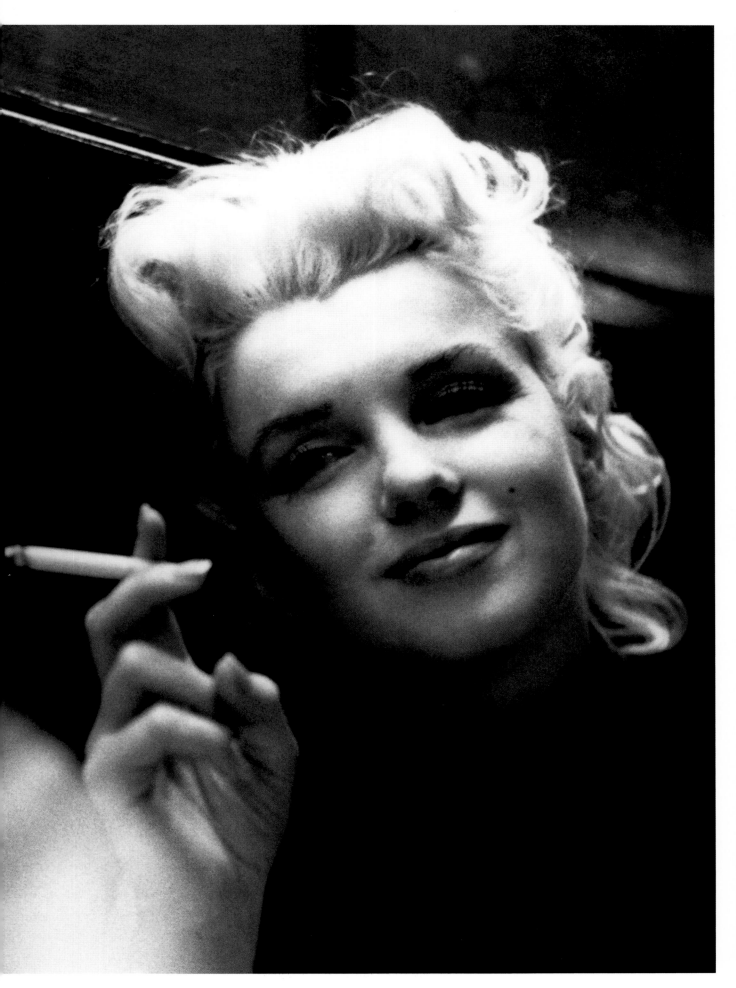

PLATES 22–24
A short break, spent at Costello's Restaurant.
Marilyn looks with evident pleasure at the wall decoration:
drawings by James Thurber.

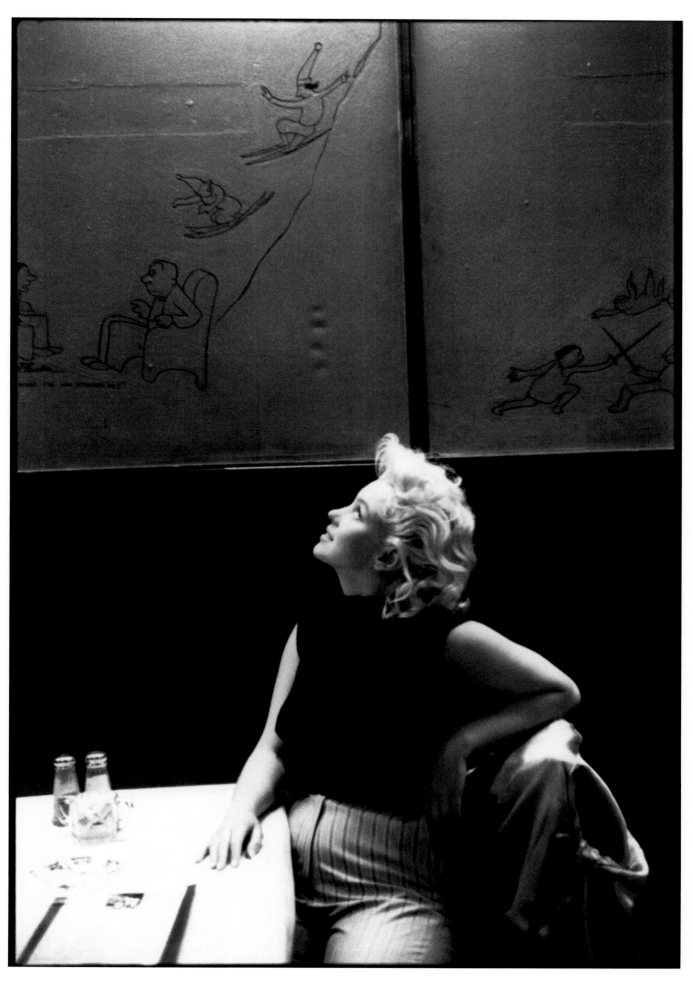

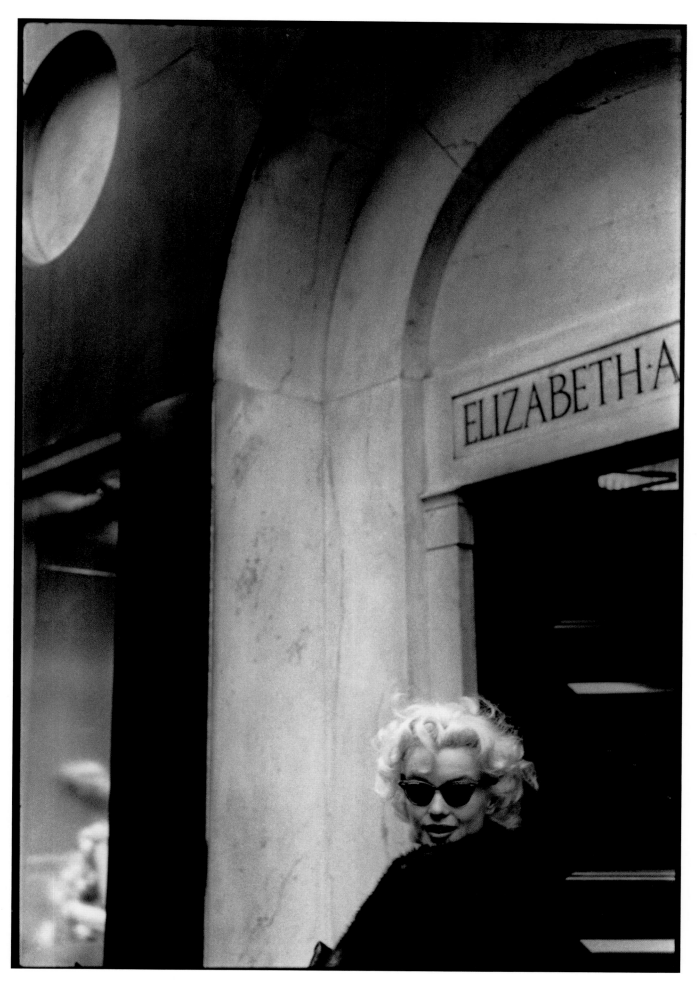

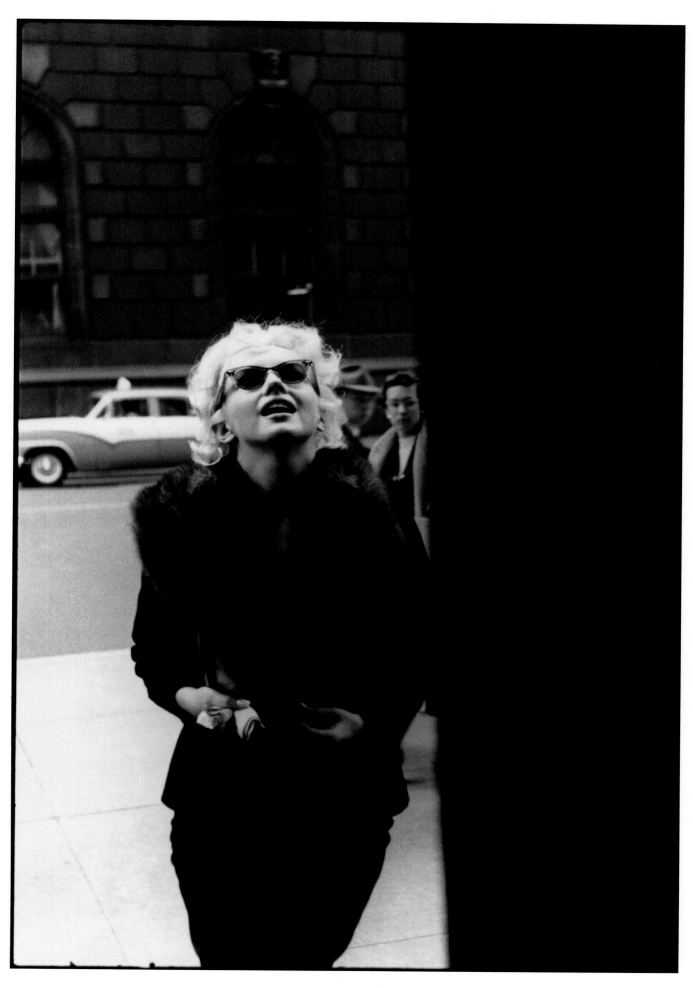

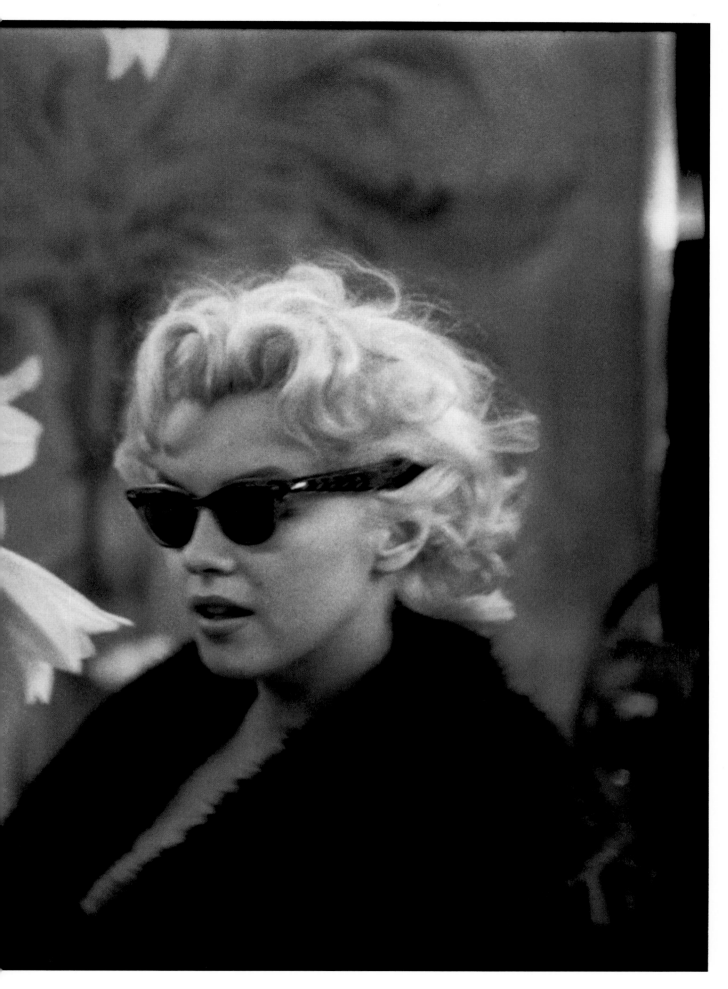

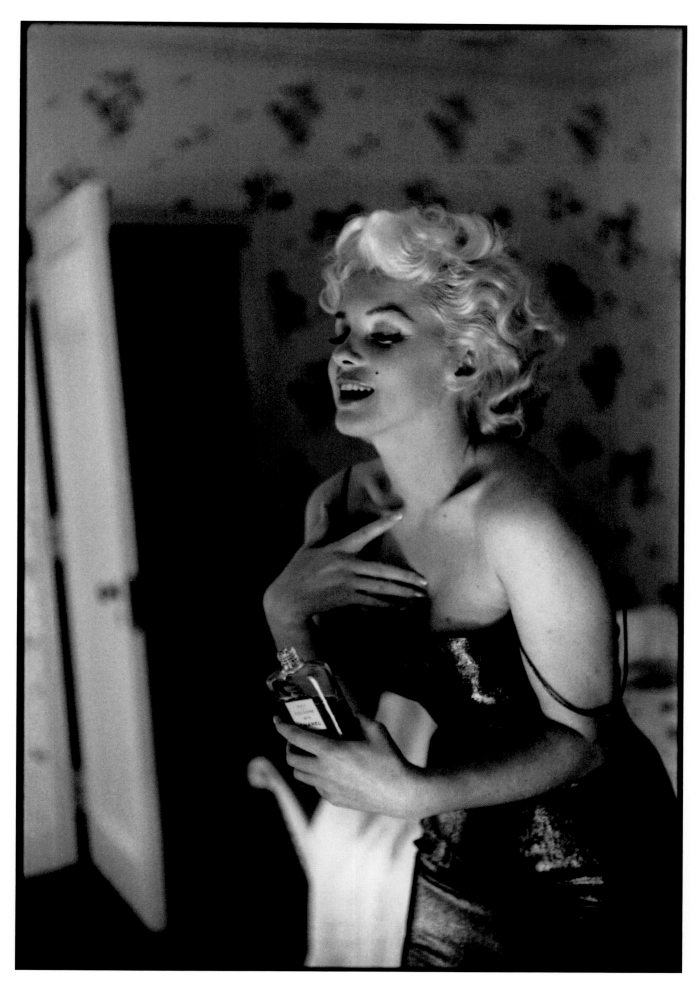

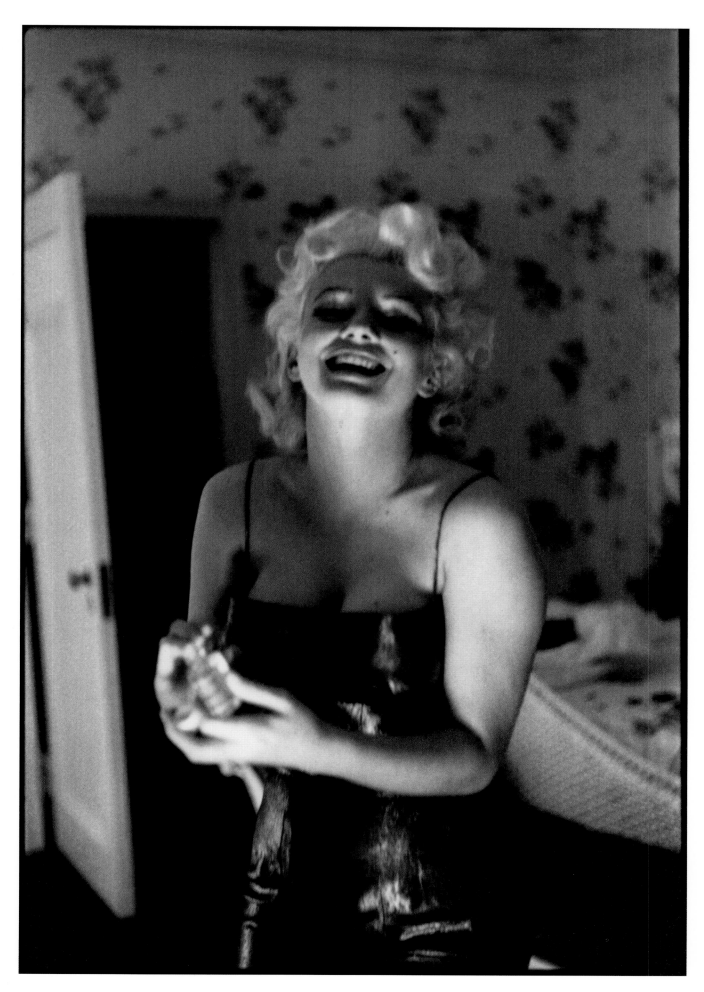

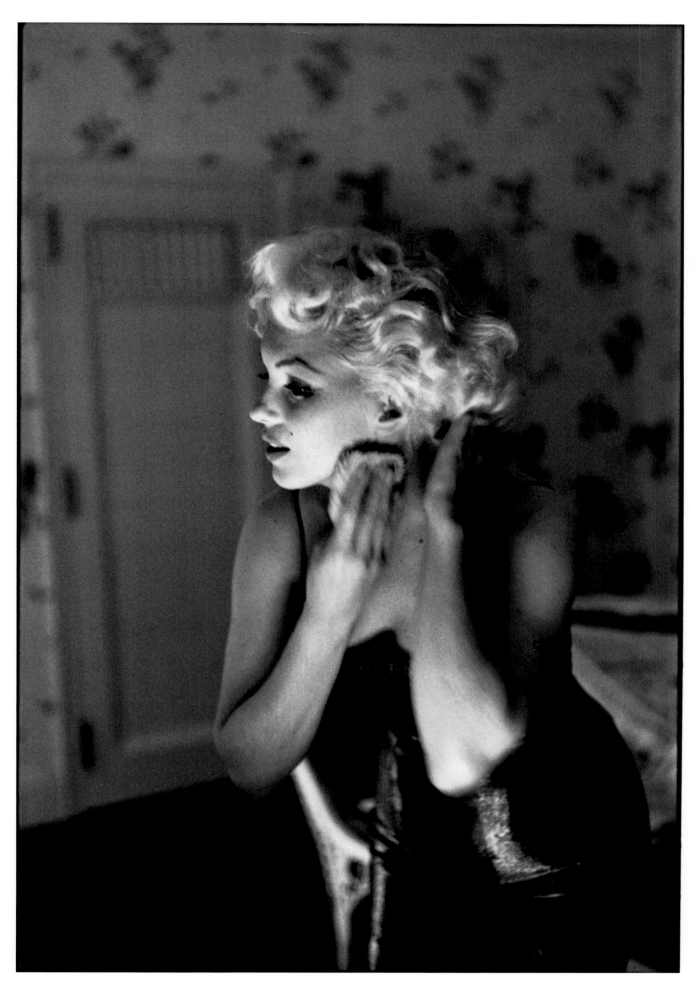

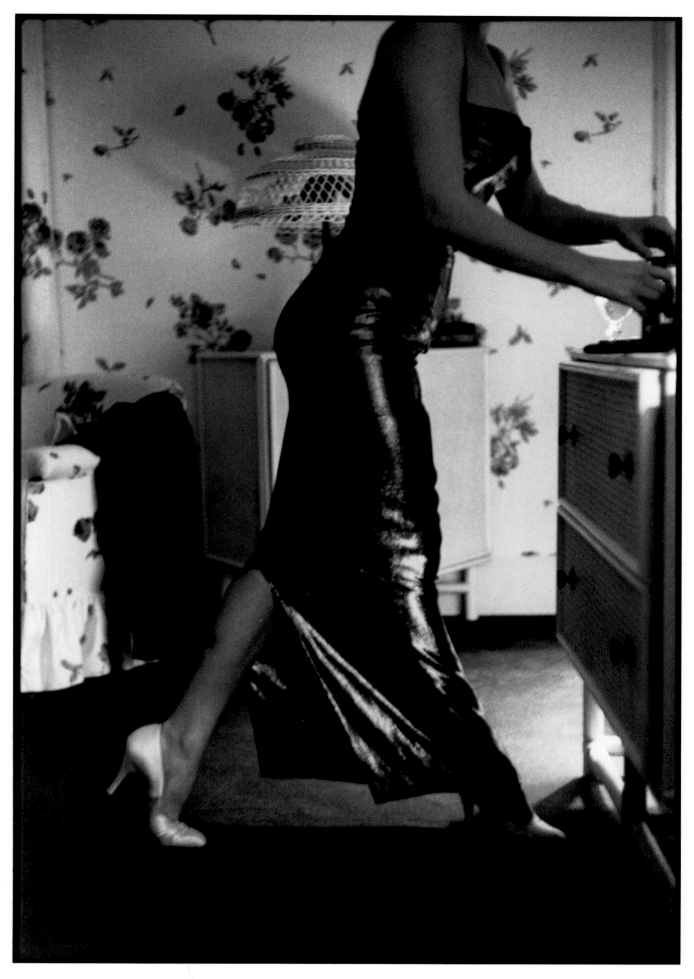

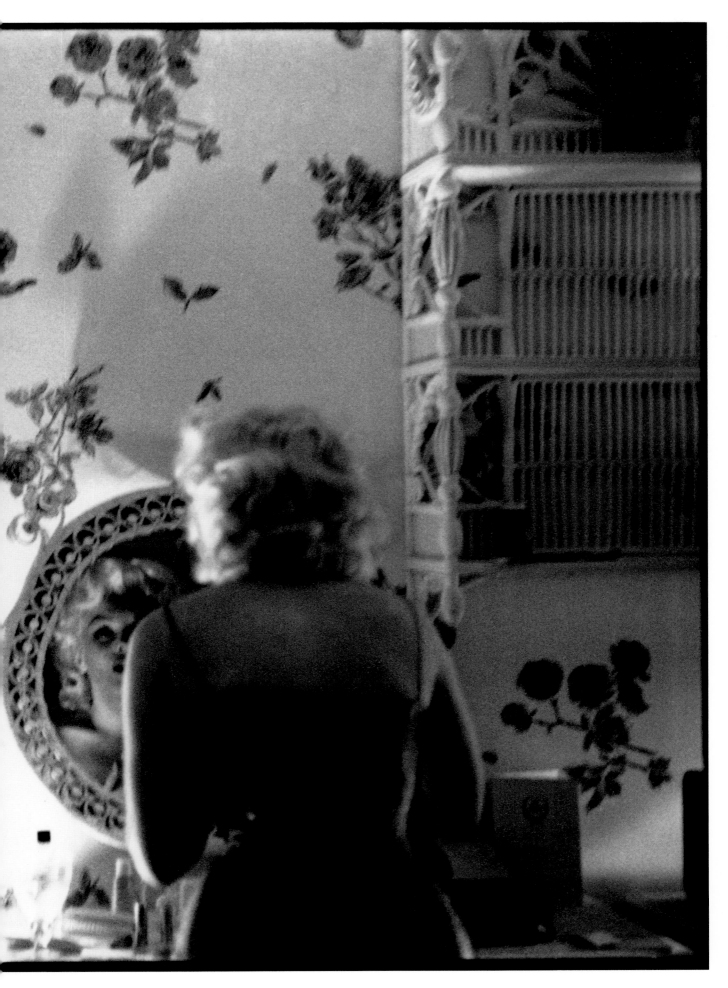

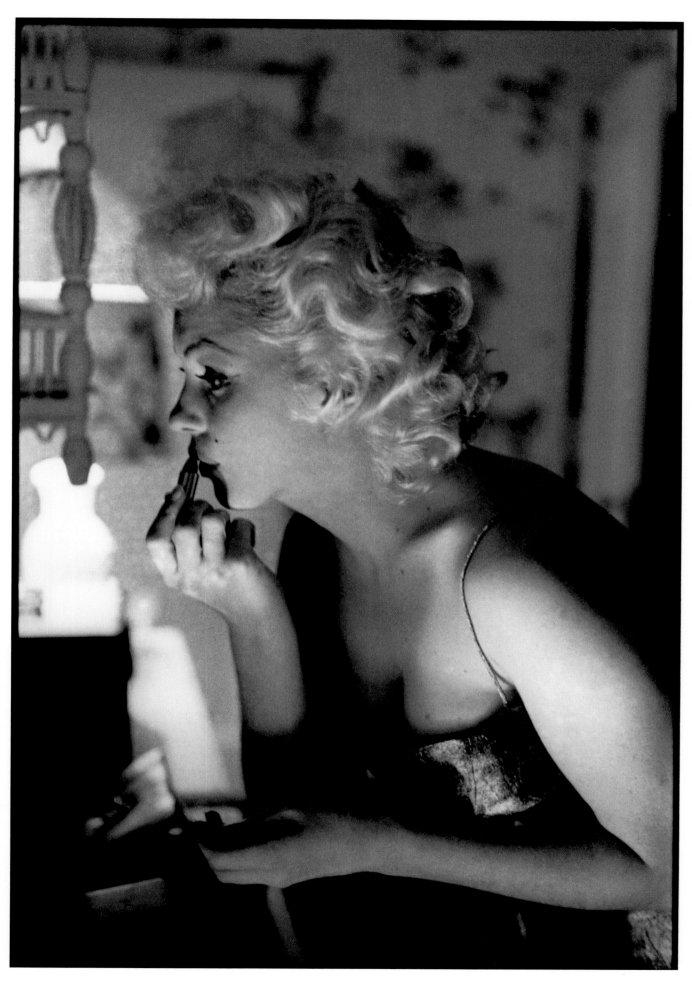

PLATE 35
In the foyer of the Morosco Theater.

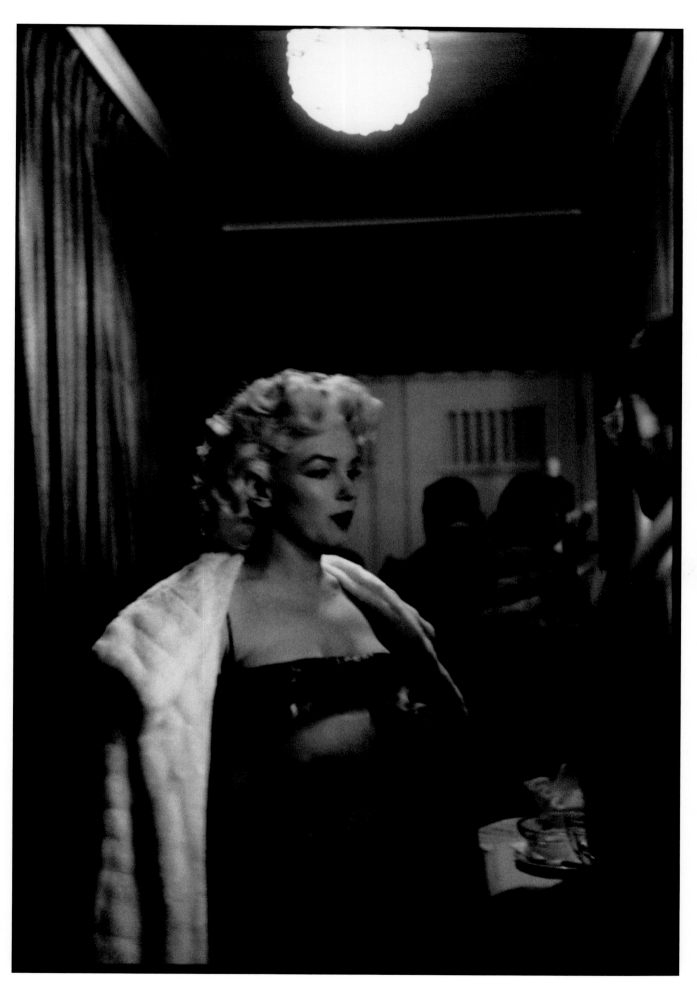

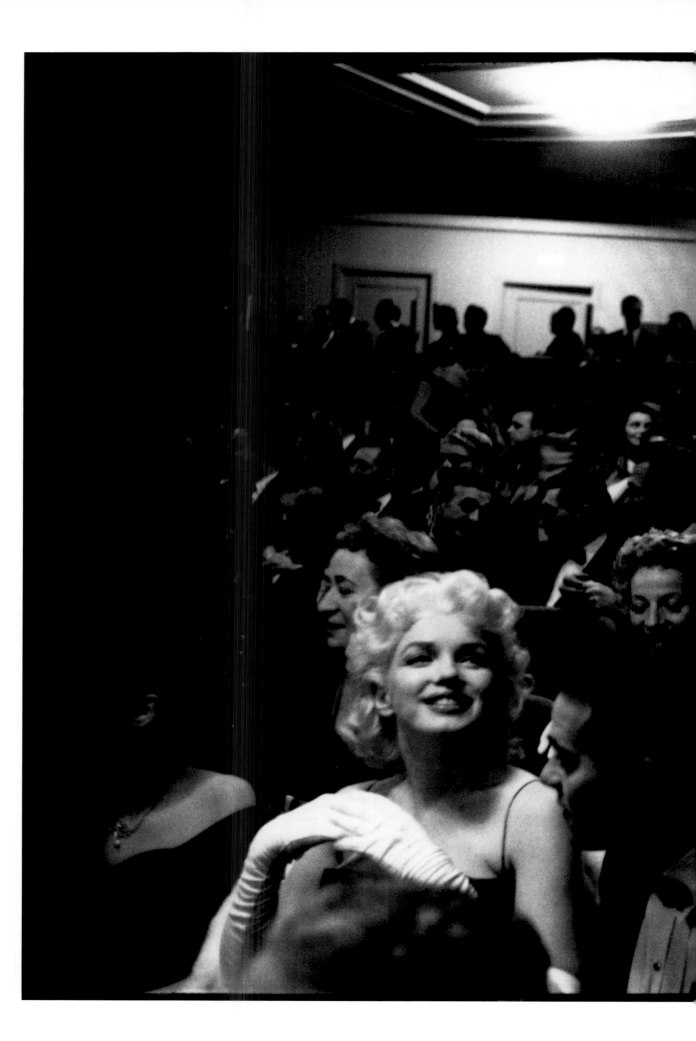

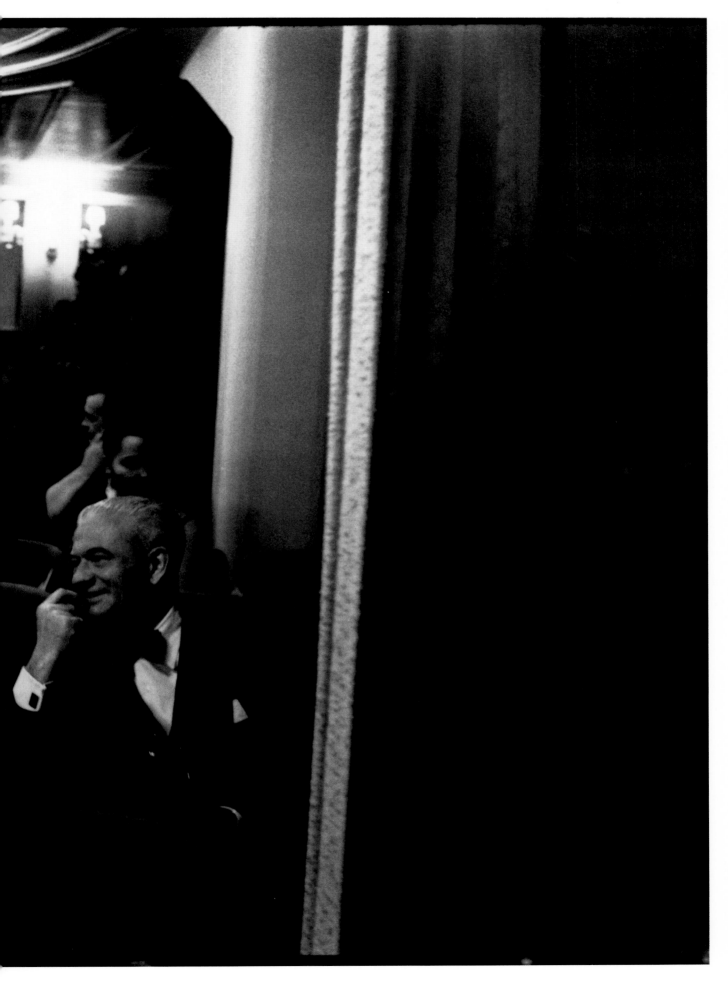

PLATES 36–39
A glance at the audience: Marilyn and, on her left,
her friend and mentor Milton Greene.

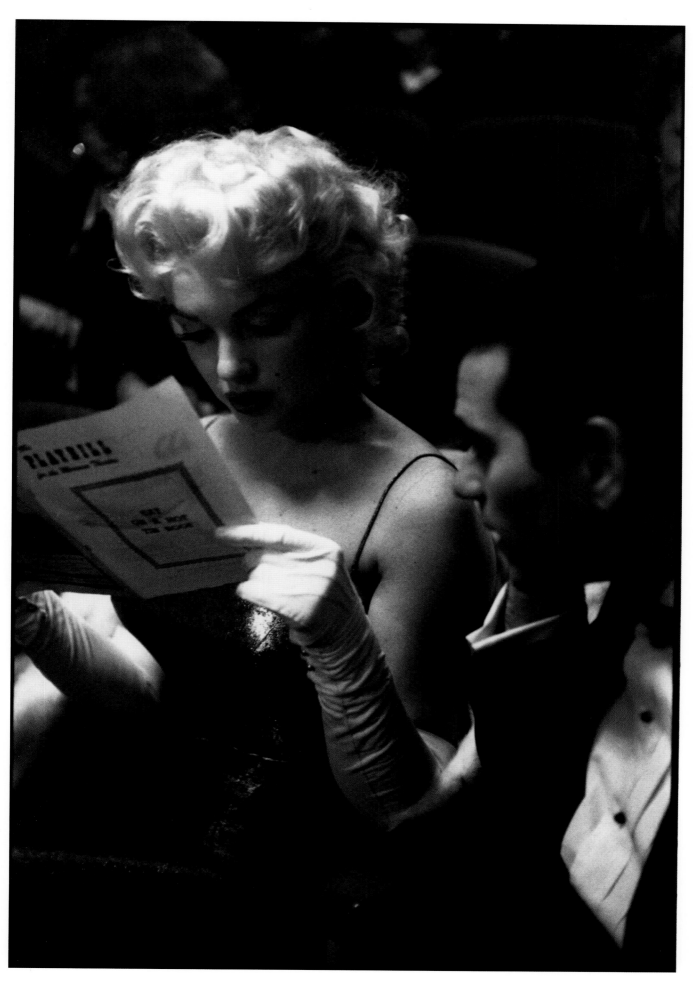

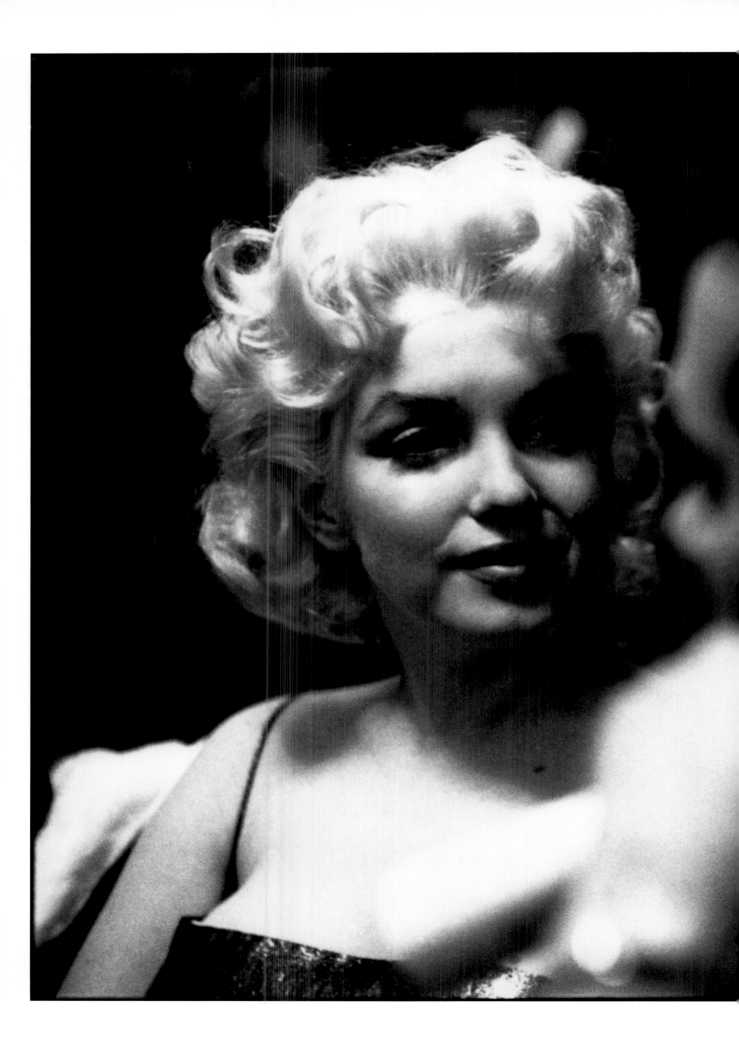

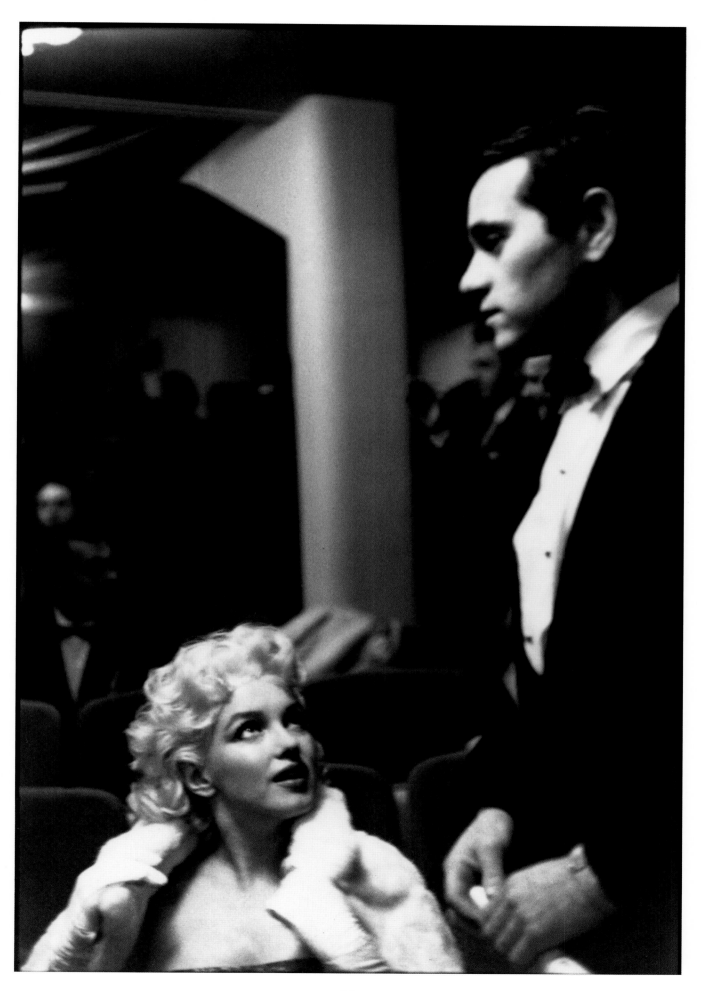

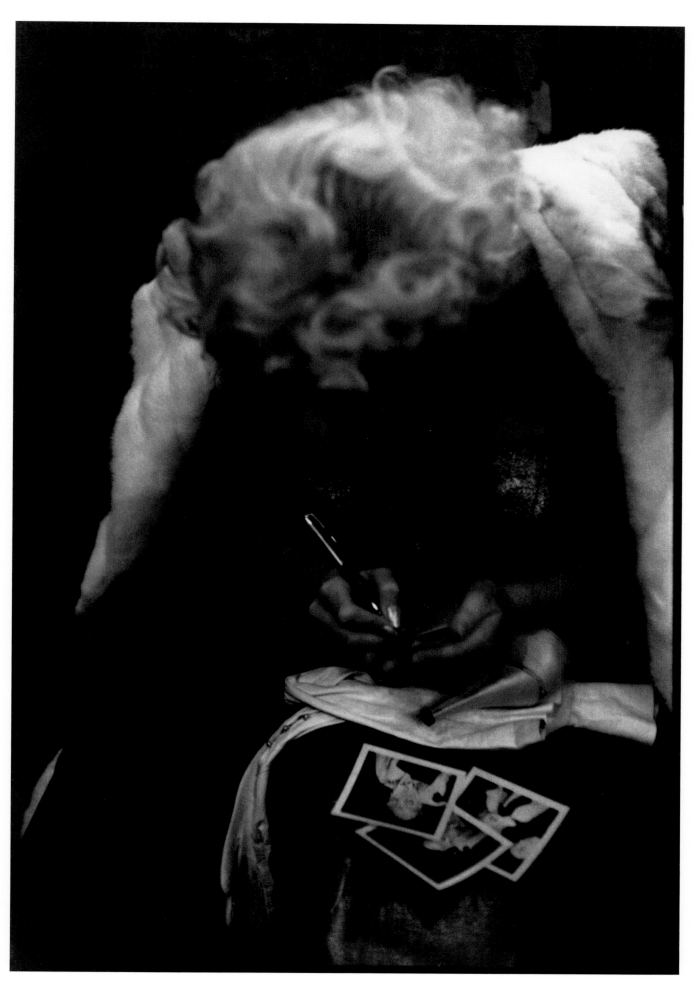

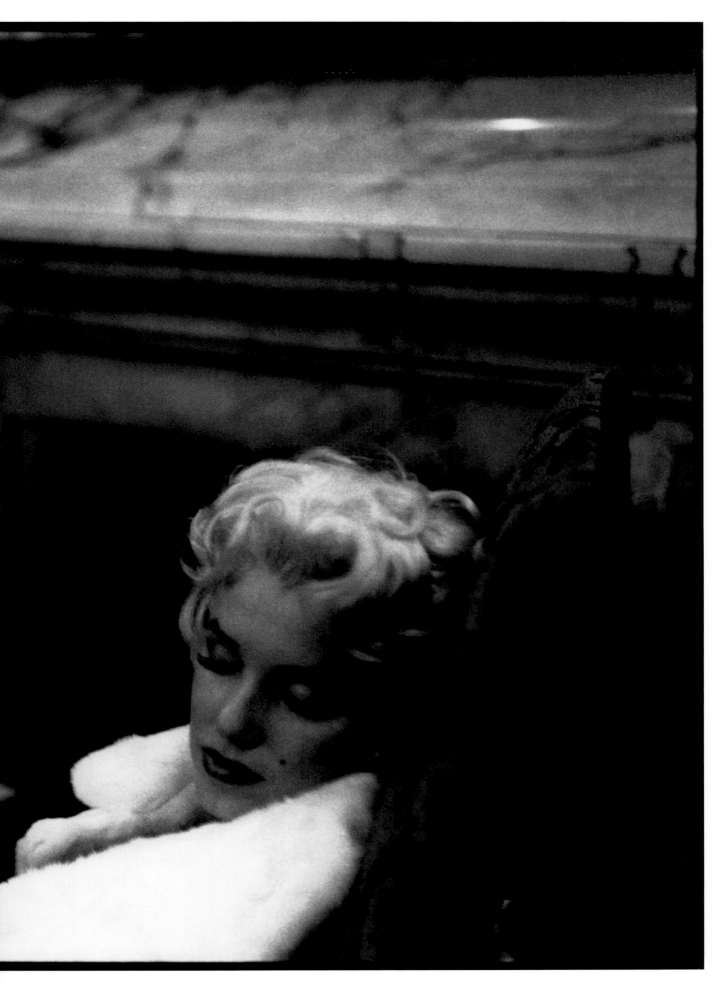

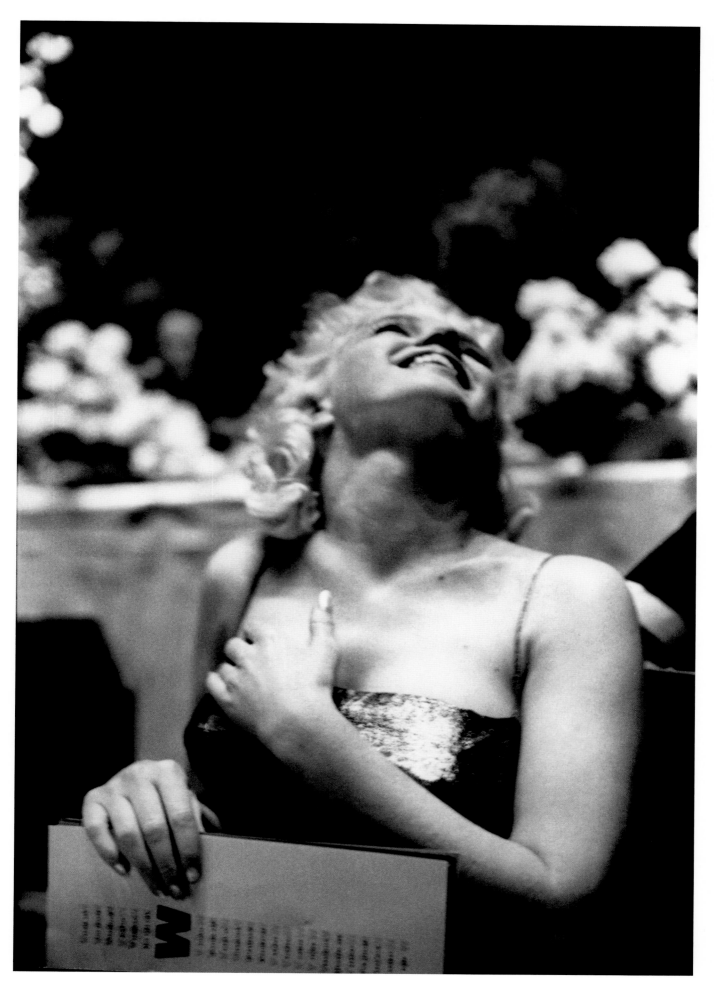

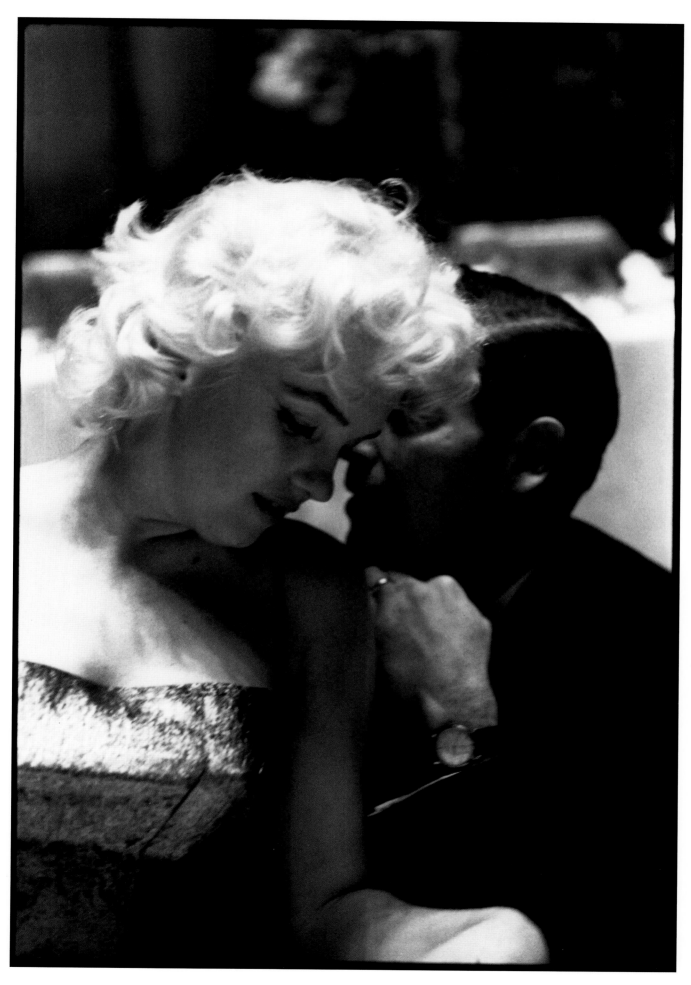

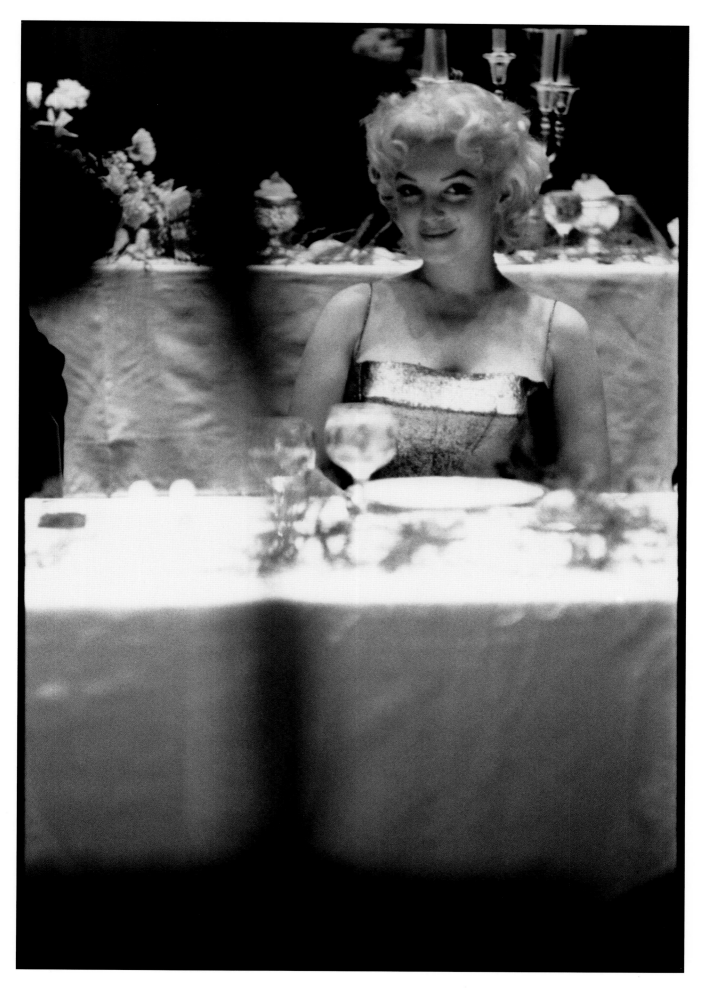

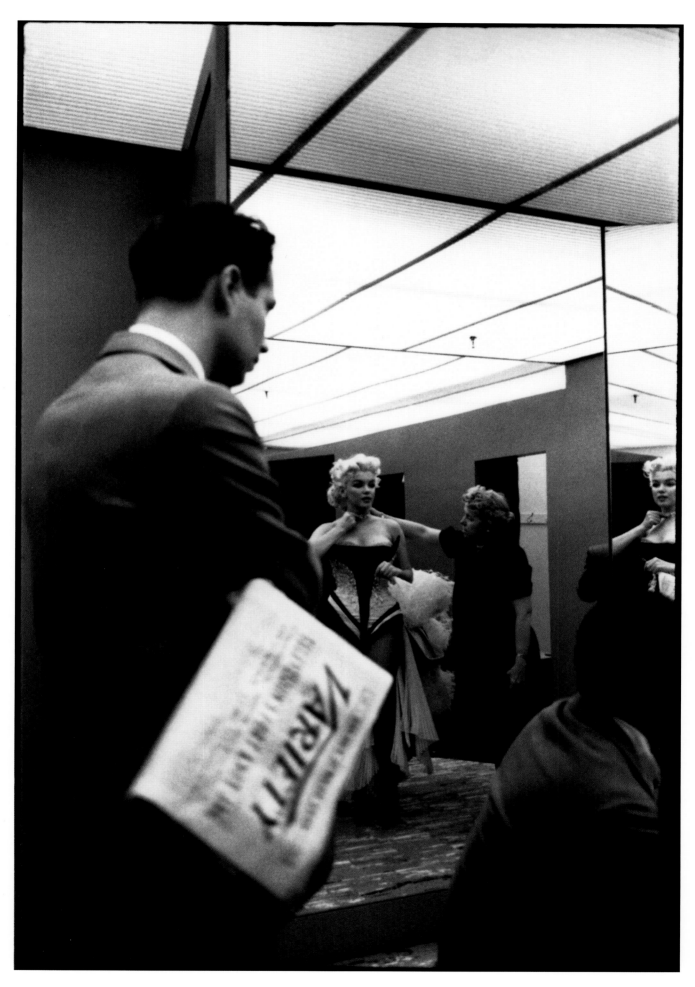

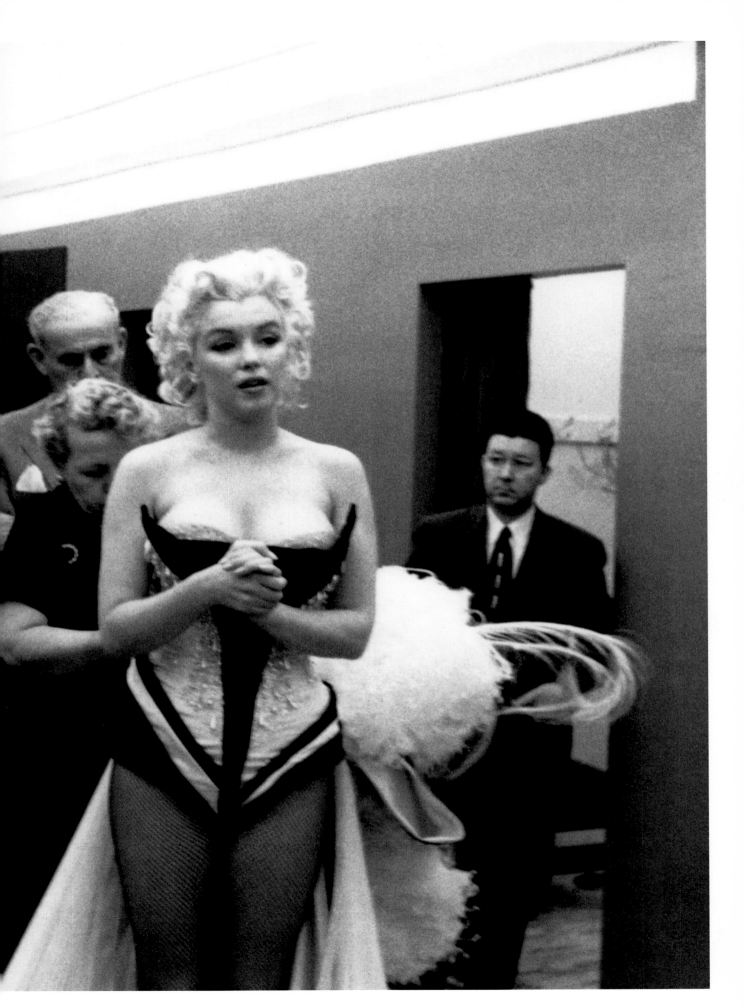

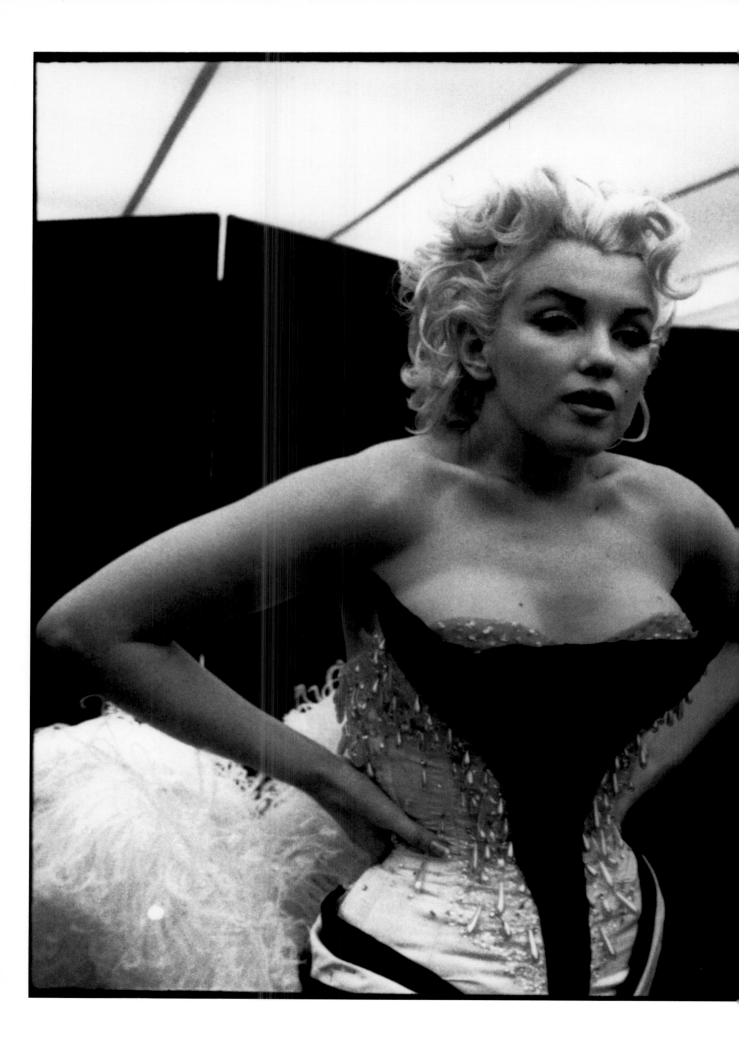

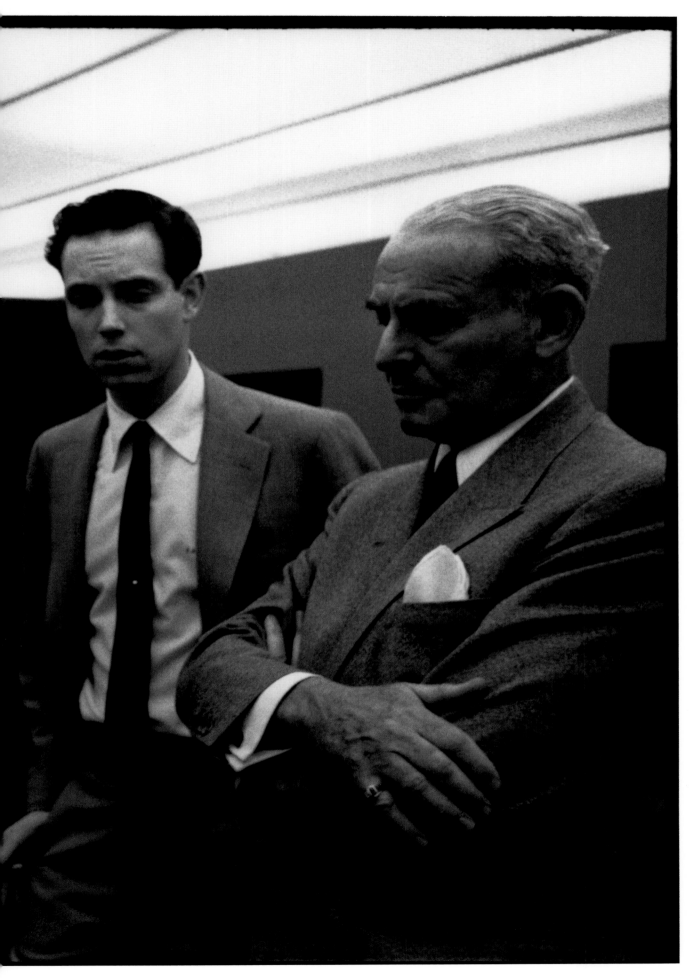

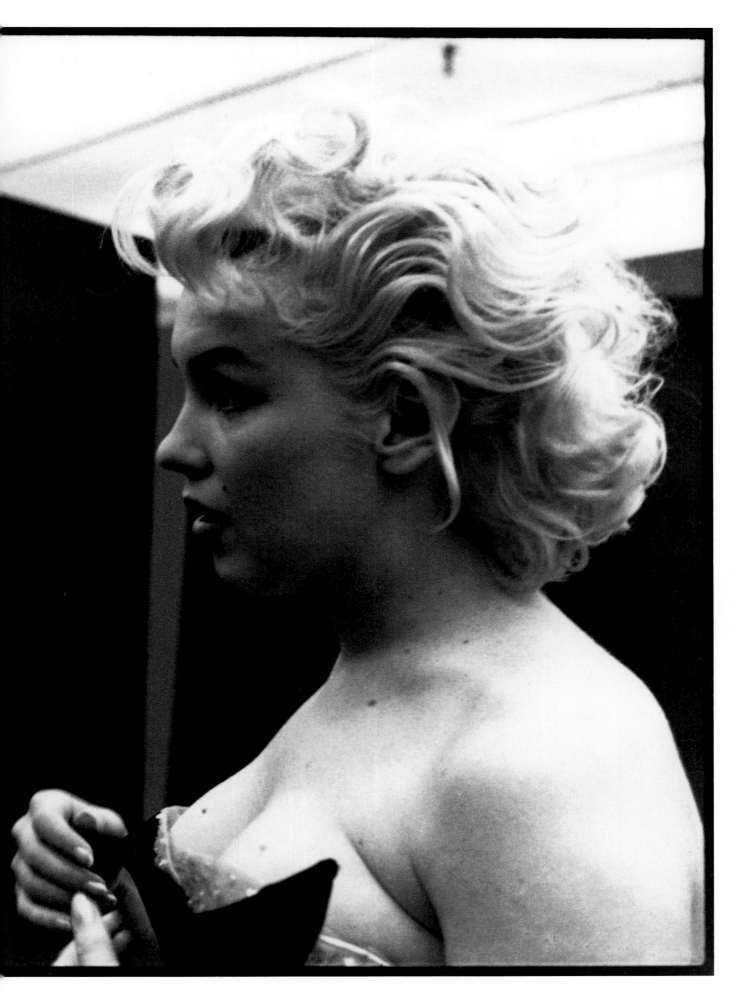

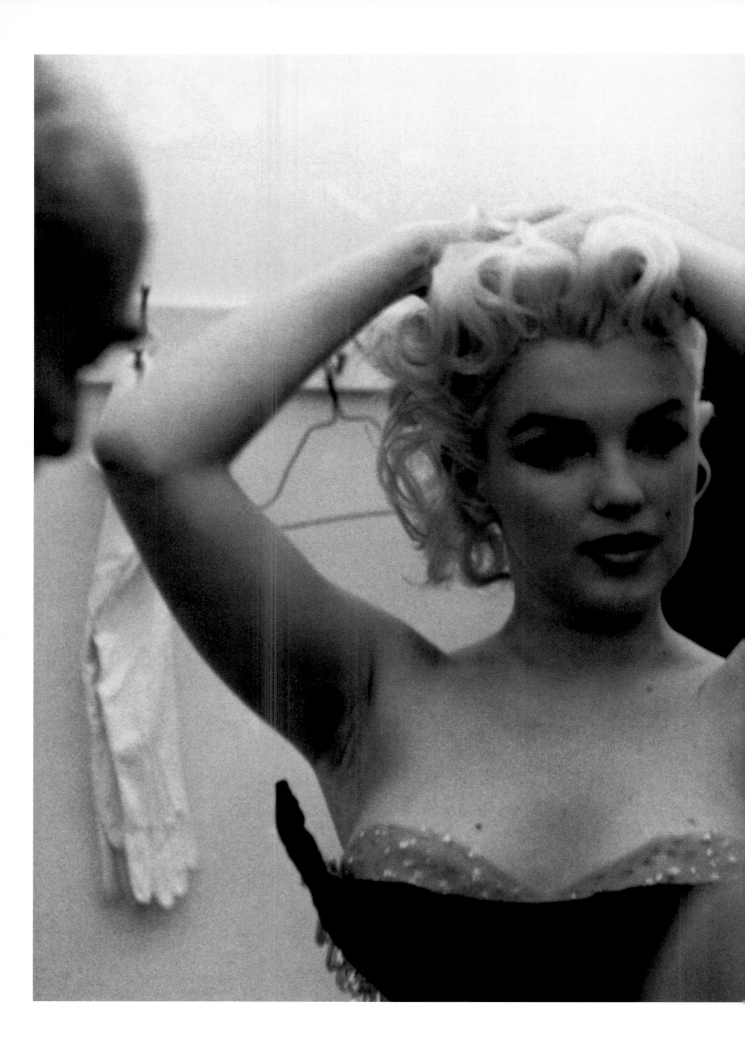

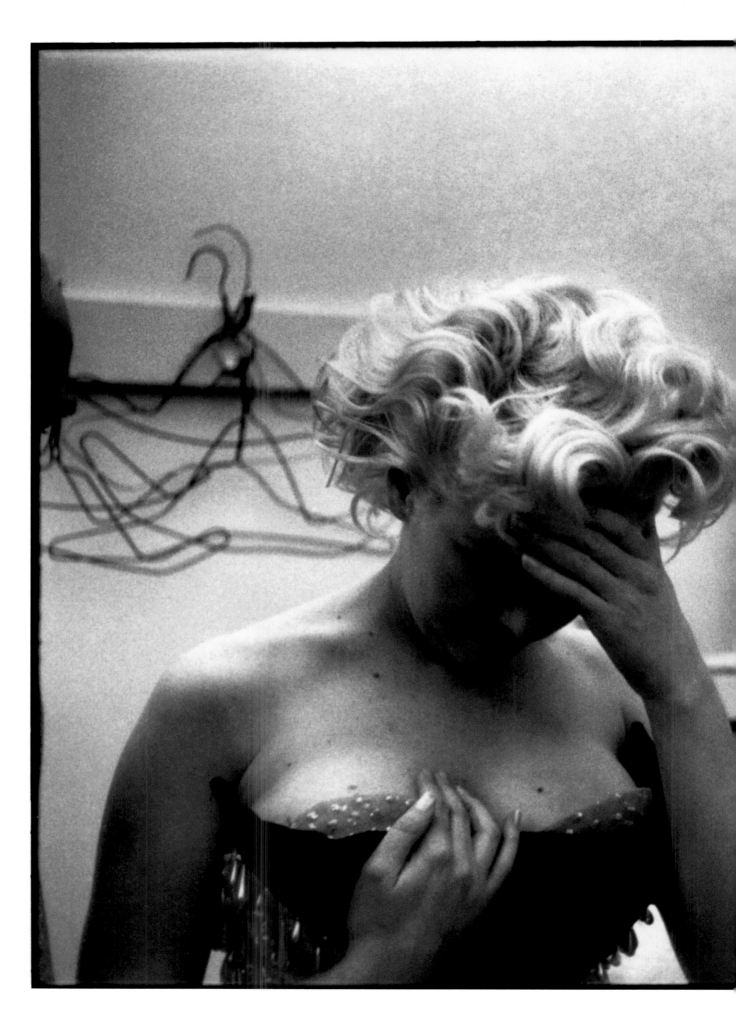

PLATE 51
*The tension subsides, Marilyn's doubt
gives way to a hearty laugh.*

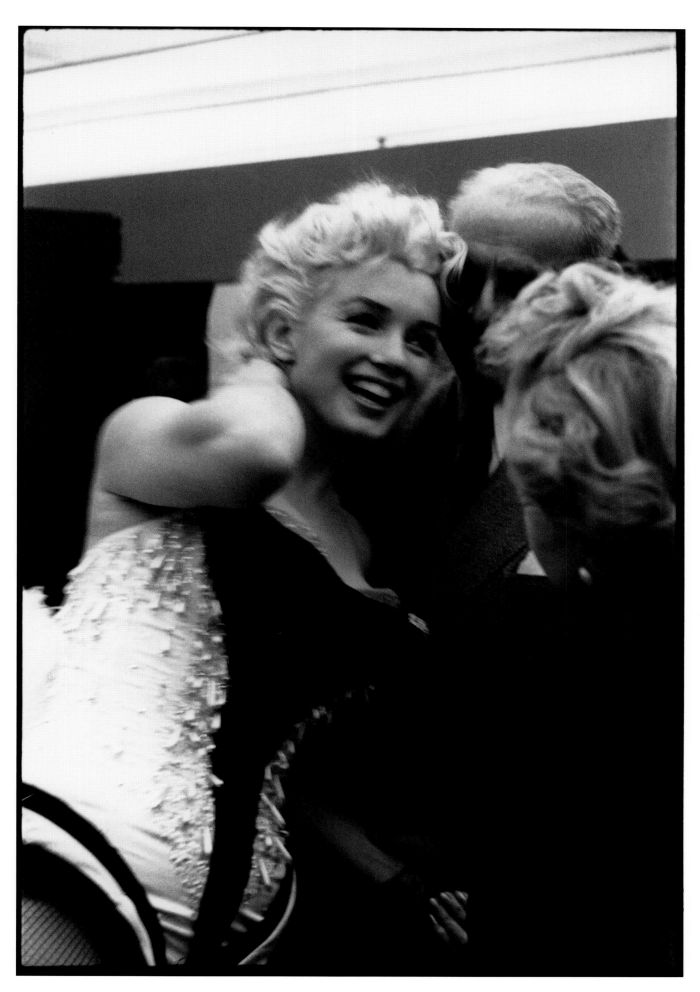

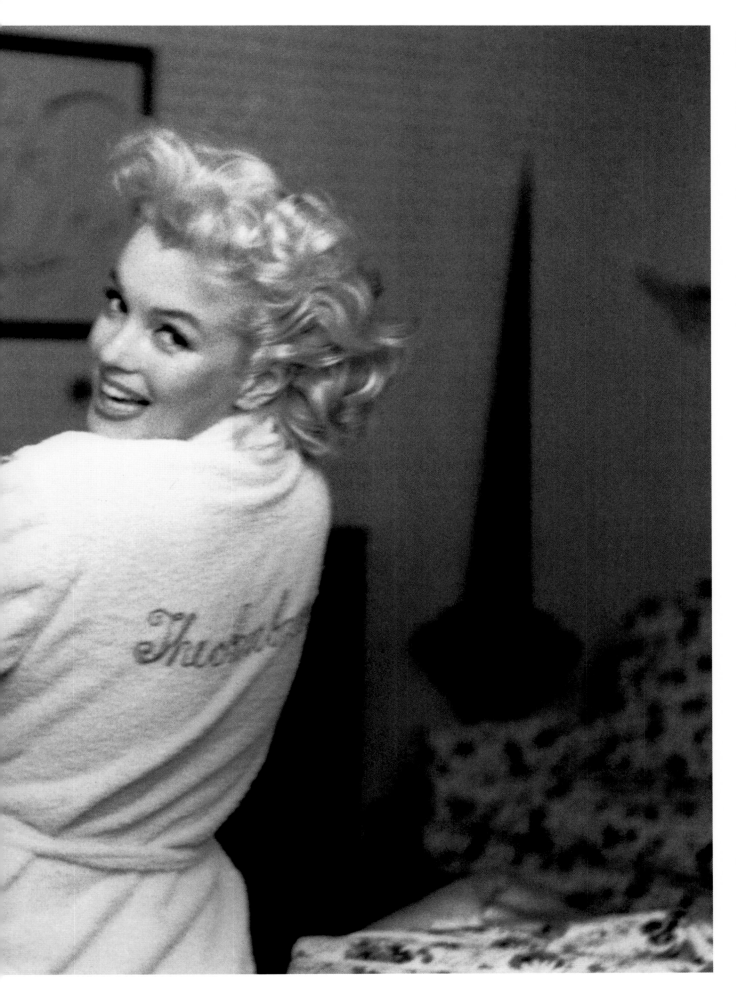

PLATES 52–56
March 30, 1955: Marilyn getting dressed for the drive
from the Ambassador Hotel to Madison Square Garden.
You might be forgiven thinking the show
had already begun.

PLATES 57–58
In the taxi on the way to the circus.

PLATES 59–62
Marilyn down in the "catacombs" at Madison Square Garden
– en route for her dressing-room.

PLATES 63–64
Marilyn's famous ride on the pink-painted elephant
is the highlight of the show. But the hordes of photographers,
who unnerve neither the elephant nor his exquisite rider,
speak for themselves.

PLATE 65
Marilyn's group portrait with circus performers.

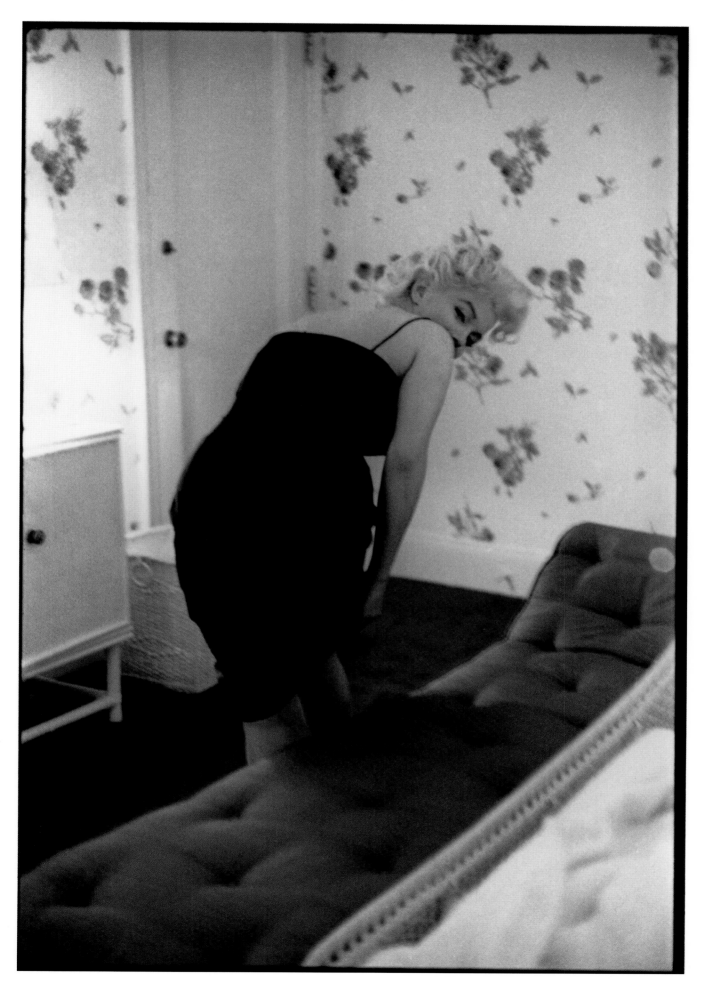

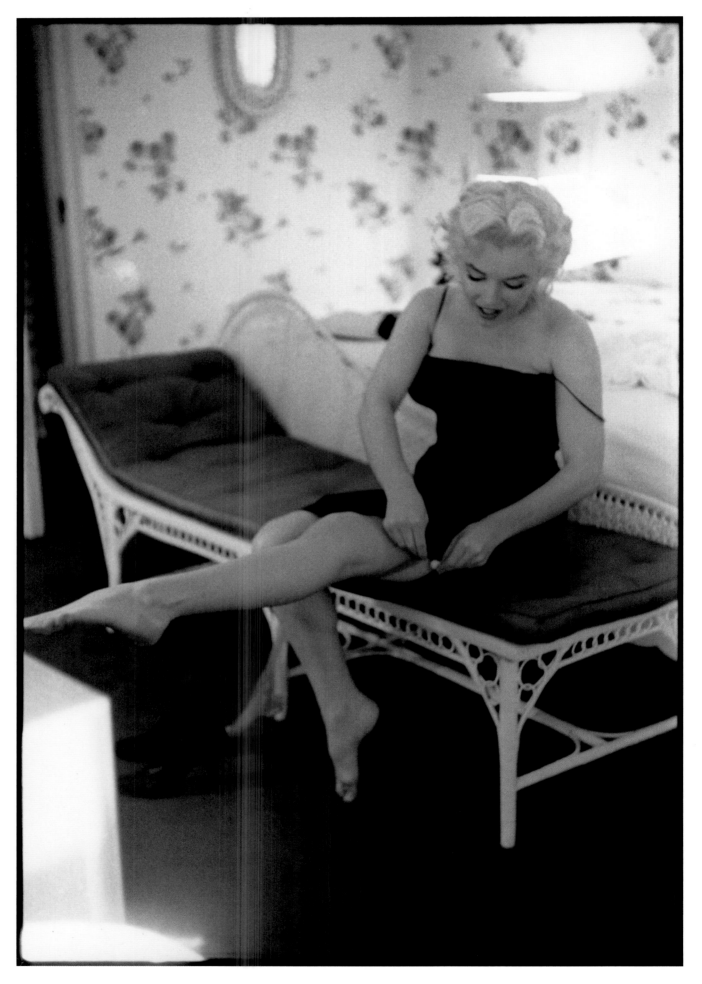

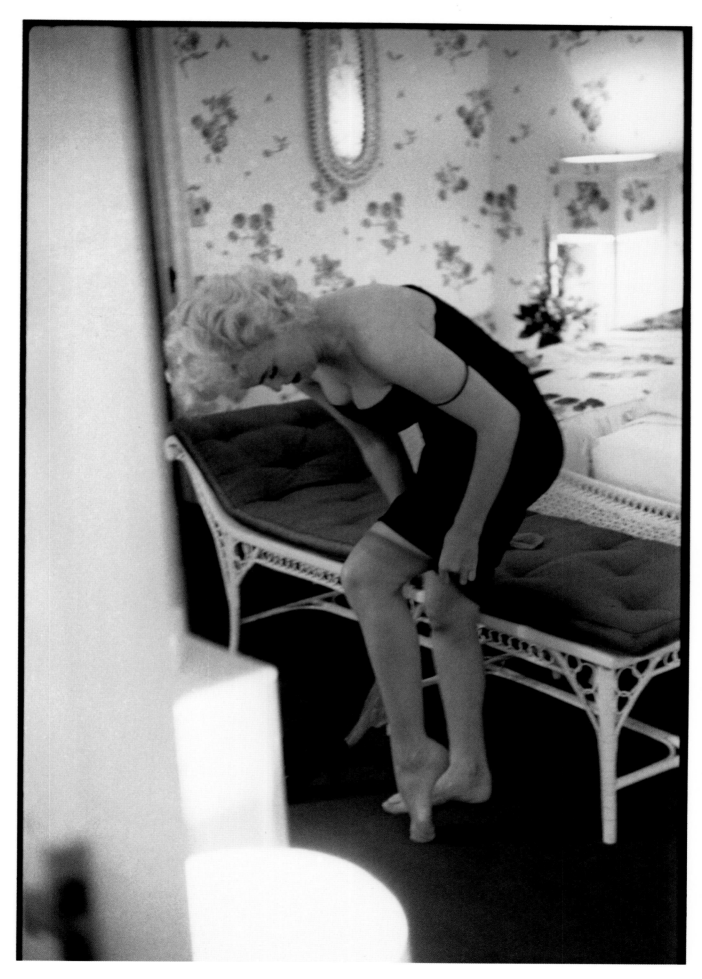

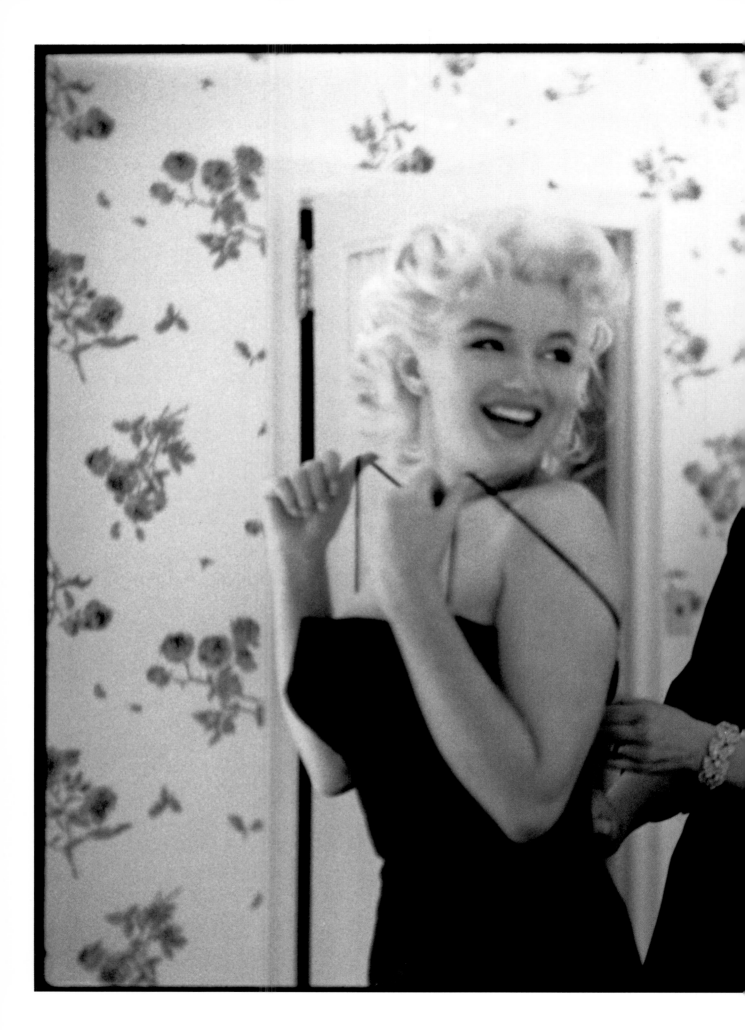

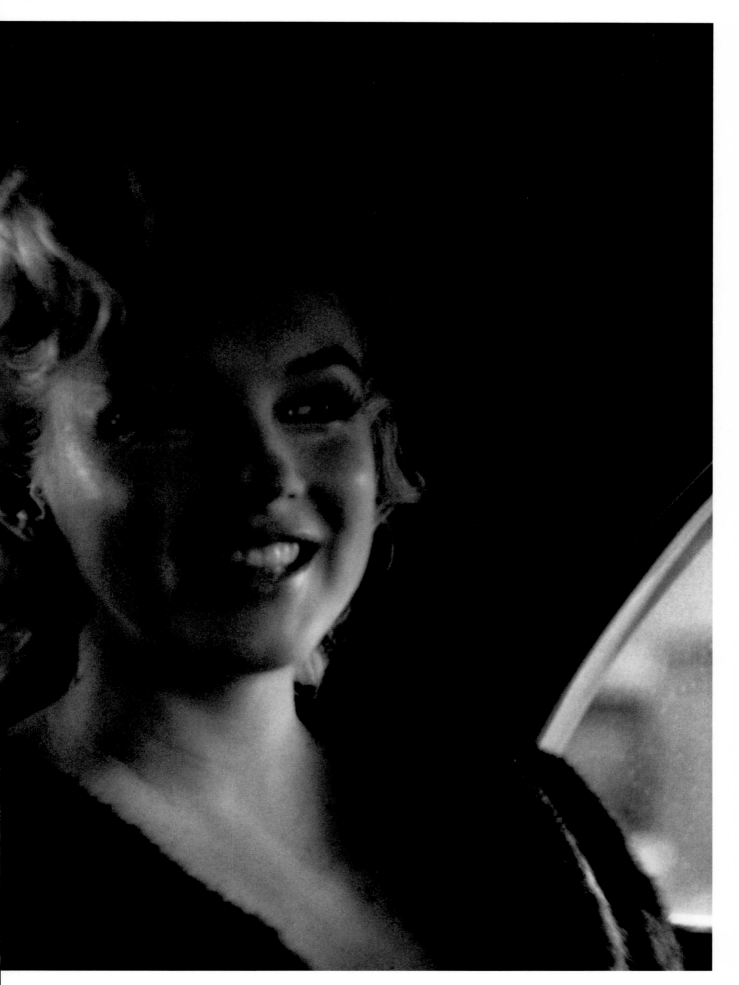

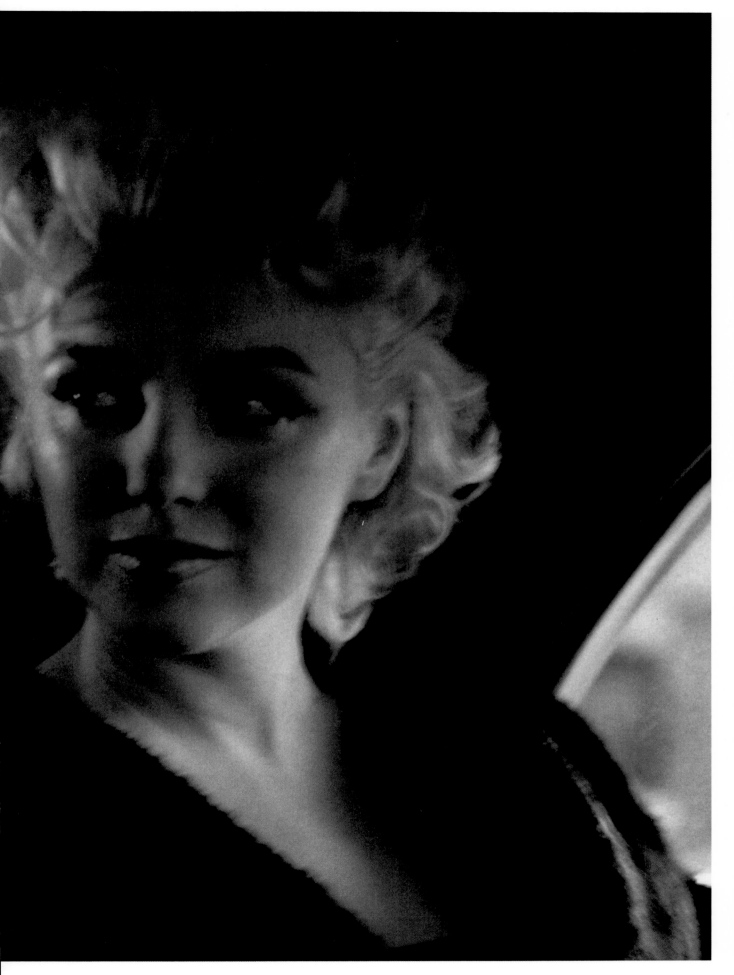

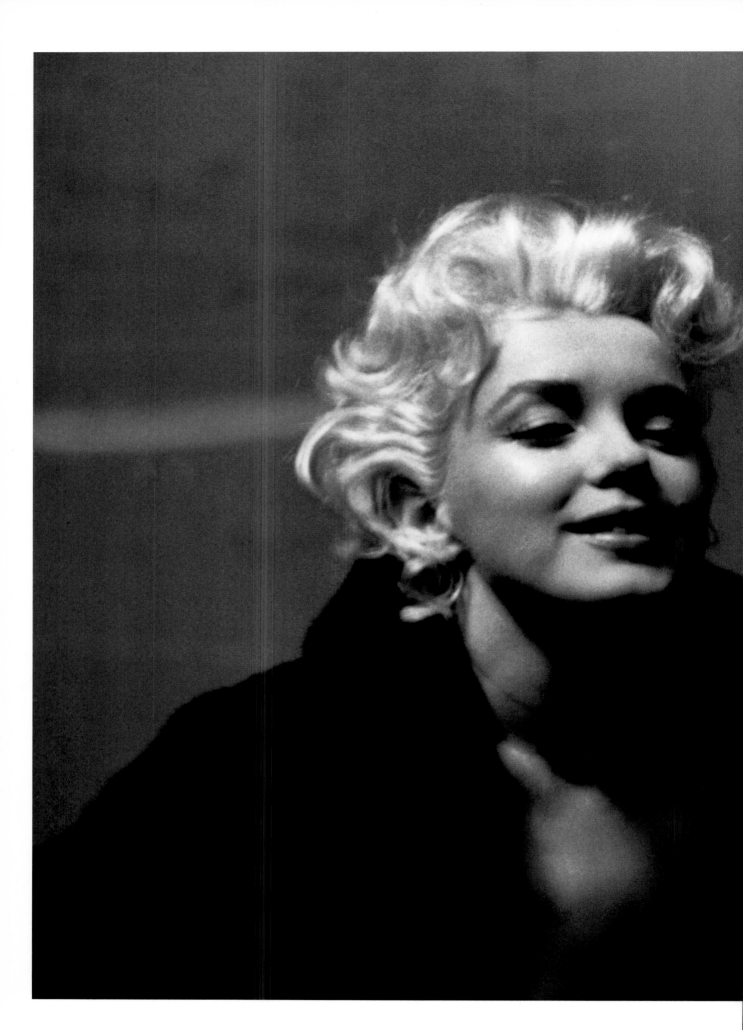

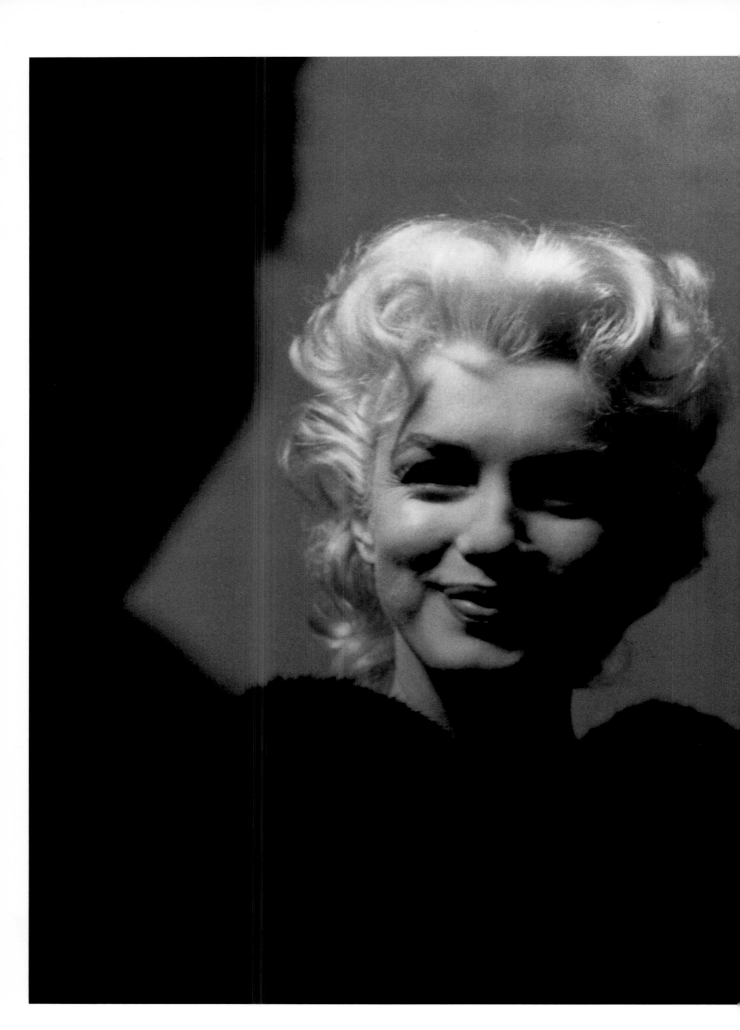

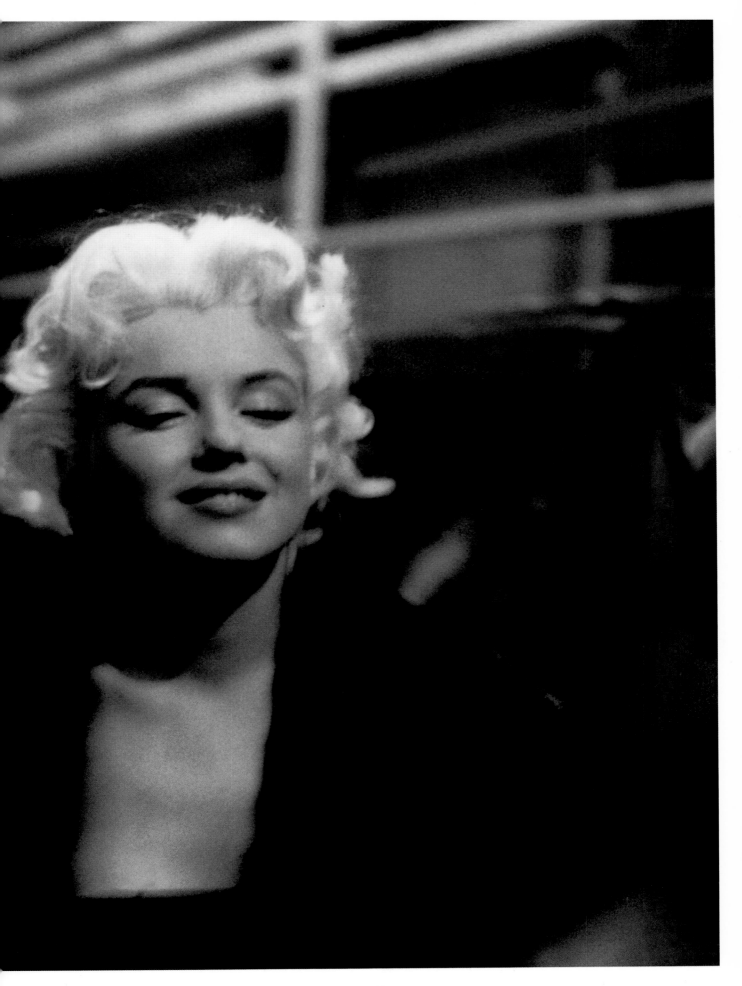

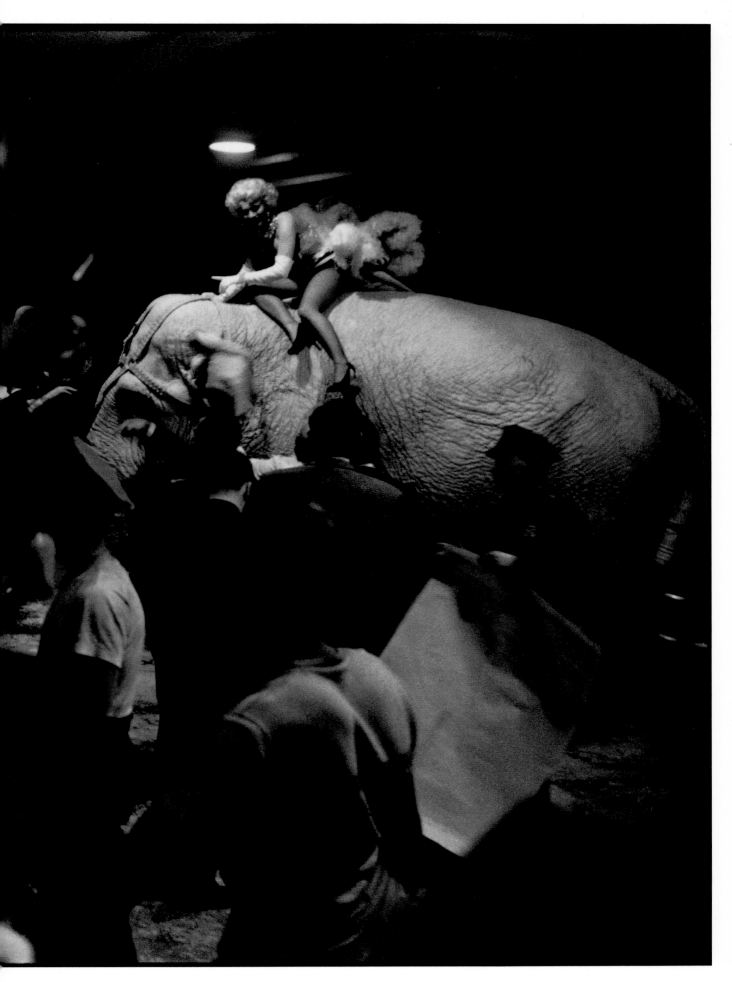

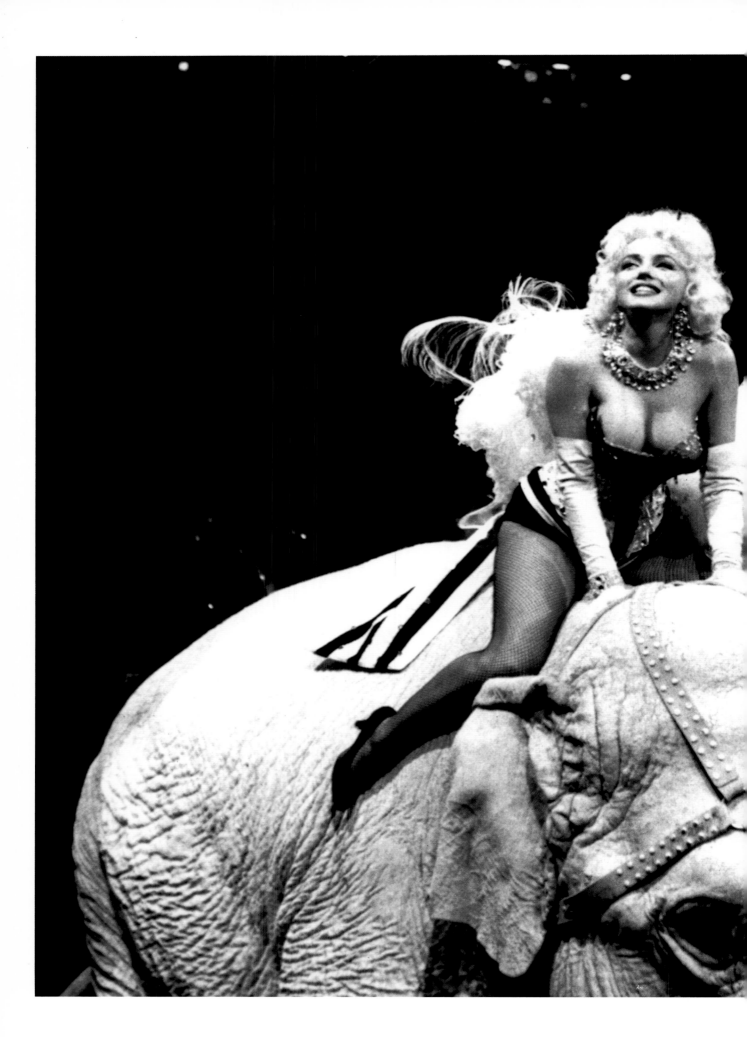

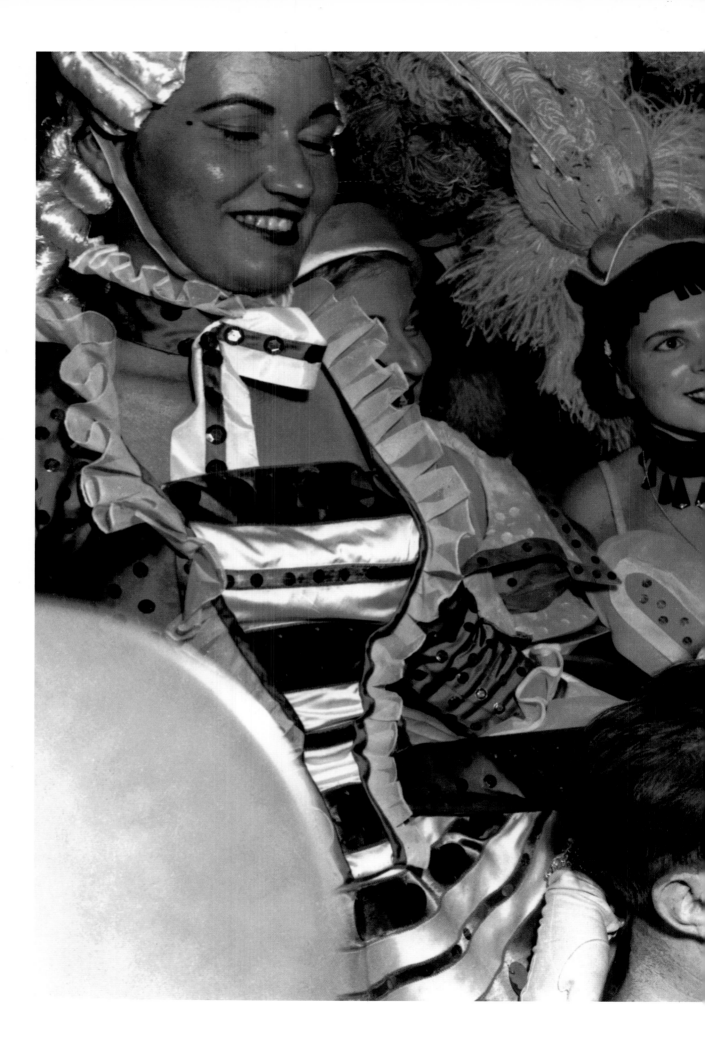

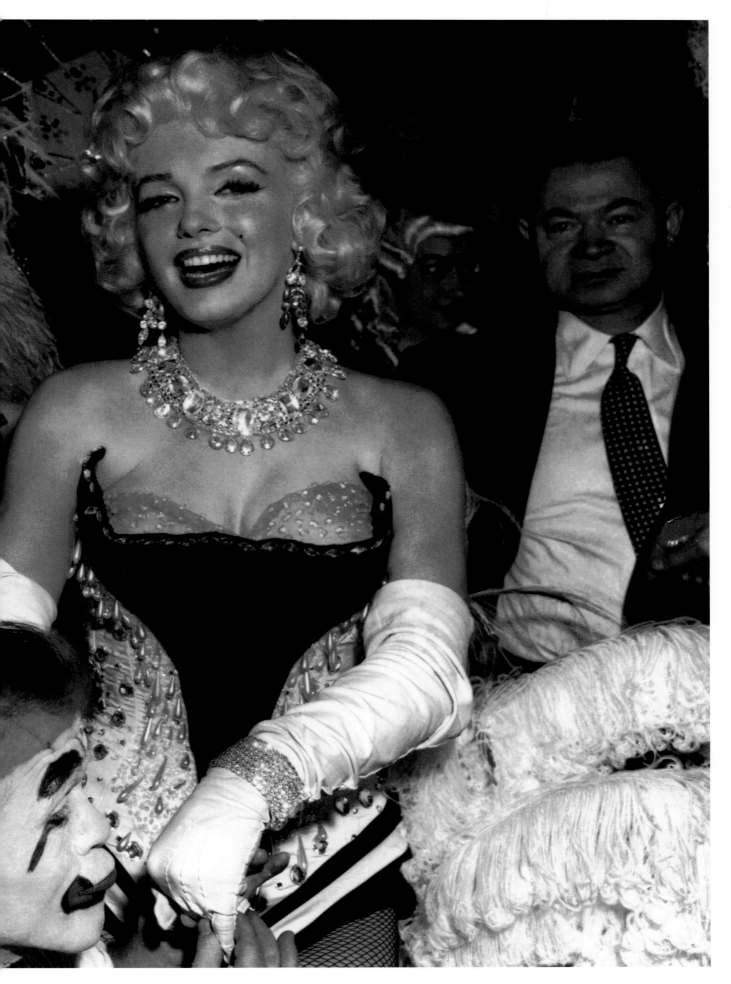